LAST BARRIERS

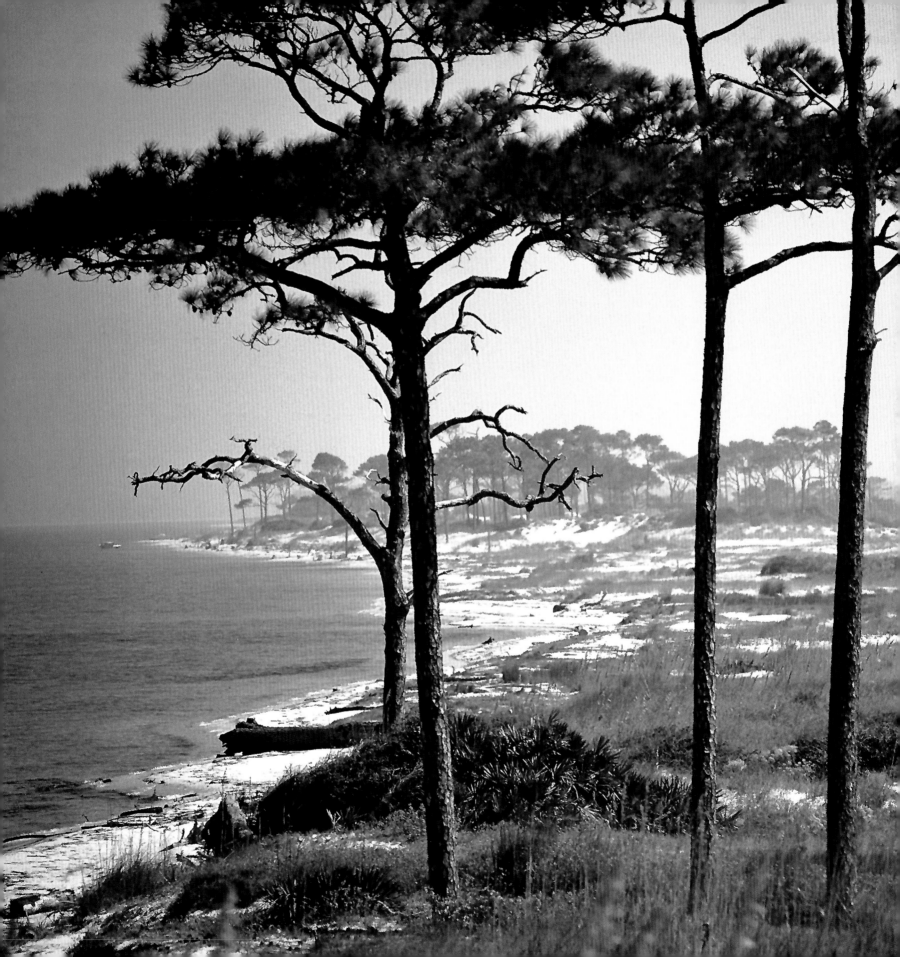

LAST BARRIERS

Photographs of Wilderness in the Gulf Islands National Seashore

Donald Muir Bradburn

UNIVERSITY PRESS OF MISSISSIPPI / JACKSON

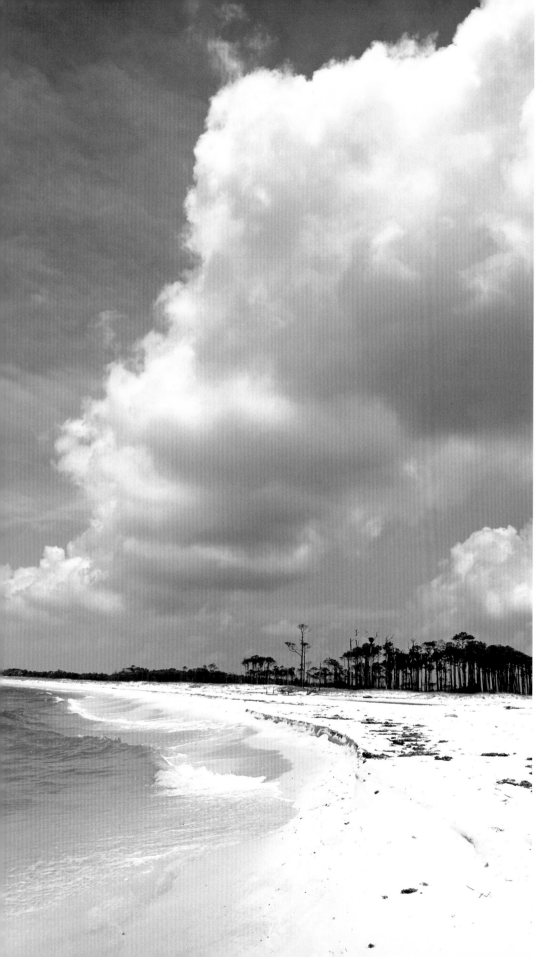

www.upress.state.ms.us

Designed by Peter D. Halverson

The University Press of Mississippi is a member of the Association of American University Presses.

Printed in China by Everbest through
Four Colour Imports, Ltd., Louisville, Kentucky

First printing 2011
∞
Library of Congress Cataloging-in-Publication Data

Bradburn, Donald Muir.
 Last barriers : photographs of wilderness in the Gulf Islands National Seashore / Donald Muir Bradburn.
 p. cm.
 ISBN 978-1-60473-981-7 (cloth : alk. paper) — ISBN 978-1-60473-982-4 (ebook)
 1. Gulf Islands National Seashore (Fla. and Miss.)—Pictorial works. 2. Horn Island (Miss.)—Pictorial works. 3. Wilderness areas—Gulf Islands National Seashore (Fla. and Miss.)—Pictorial works. 4. Natural history—Gulf Islands National Seashore (Fla. and Miss.)—Pictorial works. 5. Landscapes—Gulf Islands National Seashore (Fla. and Miss.)—Pictorial works. 6. Gulf Islands National Seashore (Fla. and Miss.)—Environmental conditions. 7. Horn Island (Miss.)—Environmental conditions. 8. Gulf Islands National Seashore (Fla. and Miss.)—Description and travel. 9. Horn Island (Miss.)—Description and travel. I. Title.
 F347.G9B73 2011
 975.9'99—dc22 2010033290

British Library Cataloging-in-Publication Data available

FOR ANNE, MUIR, AND HELEN

and

FOR ALL THOSE WHO WROTE LETTERS OR CAME TO A PUBLIC HEARING
IN SUPPORT OF THE CITIZEN'S WILDERNESS PLAN

CONTENTS

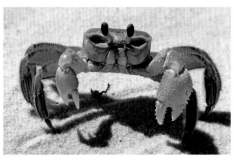

LAST BARRIERS

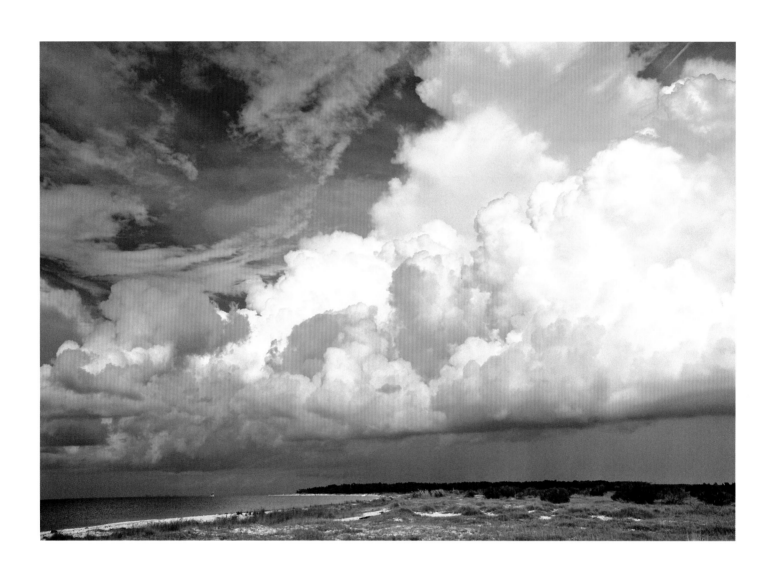

SAVING HORN AND PETIT BOIS ISLANDS

The History of a Campaign for Wilderness

For as long as I can remember, I have been fascinated by the natural world and its denizens. I grew up in the city, where the most easily observed fauna of the natural world were birds, so that I, along with a small cadre of friends, became an avid bird watcher at a time when such an activity was considered distinctly odd. I looked forward to weekends when we would ride our bicycles to the New Orleans lakefront (then largely undeveloped) or when some adult would drive us out beyond the city limits where, in the woods and swamps, lurked new and previously unseen birds and animals.

I spent many summers of my childhood on the Gulf Coast of Mississippi at Biloxi or Ocean Springs. I remember early summer mornings with an onshore breeze fresh from the Mississippi Sound and with trawl boats, many of them converted schooners, starting seaward from under Deer Island, their engines sounding the "pop pop pop" of the "one lungers" of that era. The laughing gulls' cries, the terns' raucous calls, and the faint odor of fish always evoke these memories. On the horizon were intermittent, often indistinct, lines of trees, all that could be seen of distant and alluring islands.

When my brother and I grew old enough, my uncle took us on what he termed "cruises," and we would spend several days or a week on his boat fishing in the vicinity of these islands, usually Ship Island, where the old quarantine station's keeper,

a Scandinavian named Bill, would sometimes provide us with mullet caught in his cast net thrown expertly from the station's pier. I don't remember ever going west to Cat Island, but we did from time to time go eastward to Horn Island, which, unlike Ship Island, had a central slash pine forest extending for most of its length. My uncle's primary purpose for these "cruises" was fishing, but as the years passed the islands themselves became my primary interest. Horn Island particularly, with its dark forests, high dunes, and deserted beaches that, once you were ashore, stretched as far as you could see, to me represented a timeless, fascinating world and unbounded freedom.

The major barrier islands of the Mississippi coast form the southern boundary of the Mississippi Sound and more or less parallel the mainland coast. They are, from east to west, Petit Bois, Horn, Ship, and Cat. Petit Bois was named for the small stand of pine forest it supports; Horn's (Isle Cornu) name allegedly refers to the powder horn one of Bienville's men lost there; Ship is so named because it served as the anchorage for the sailing ships of commerce whose draft precluded continuing into the shallower waters closer to the mainland; and Cat's name, it is said, comes from Bienville's men thinking that the raccoons there represented a variety of feline. These barrier islands are the children of wind, wave, and current and are subject to constant change of variable magnitude. Petit Bois was spawned from the

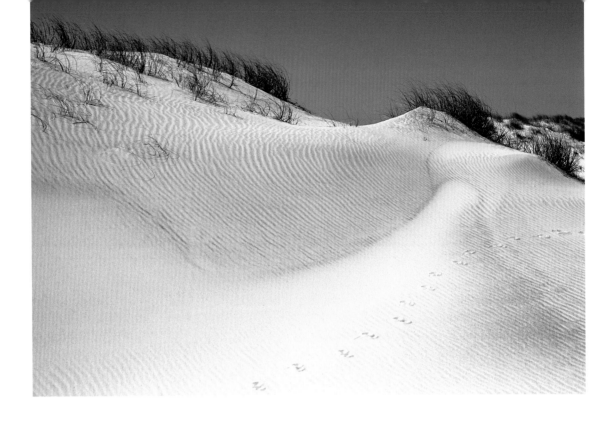

western end of Dauphin Island, Alabama's westernmost barrier island. Maps from the nineteenth and twentieth centuries show it gradually moving westward into its present position, entirely in Mississippi. This movement occurs because of a westerly long-shore current which results in the westerly drift of all of the Mississippi barrier islands. The historic Fort Massachusetts, built at the western tip of Ship Island and completed during the Civil War, now lies nearly a mile from the island's western end. Because of the island's southerly drift, the fort would likely find itself entirely within the Mississippi Sound had not the U.S. Army Corps of Engineers been persuaded to dump spoils from the nearby Gulfport ship channel around the shoreline base of the fort. The first quarantine station in the United States was constructed near the eastern end of Ship Island to protect against yellow fever, but the station, its hospital, and the little graveyard have been erased by the hurricanes of the last half of the twentieth century, which also cut the island into eastern and western halves. Cat Island is extensively wooded and was owned by a single family until its recent partial acquisition by the National Park Service. It is essentially undeveloped.

Horn Island, a bit over twelve miles long and up to three quarters of a mile at its widest, was home to a family who lived there from 1845 to 1920 and raised cattle. Only a few scattered bricks and shards of glass with a faint purplish hue due to years of exposure to brilliant sunlight remain as evidence of the location of their house. A lighthouse near the eastern tip of Horn Island was carried away, along with its keeper and his family, in the hurricane of 1906. During World War II, the U.S. Army built a biological weapons testing site with barracks and administration facilities in the central portion of the island and an incinerator at some distance to the west, close to the north shore, with a connecting narrow gauge railroad. The passage of time and multiple storms have erased almost all evidence of this activity except for a pile of scattered bricks marking the site of a now-collapsed chimney at the incinerator site. After the war, the army site was abandoned, and the island came under the jurisdiction of the U.S. Fish and Wildlife Service, which constructed a small cabin close to the area of the former army barracks and managed the island as part of the Breton National Wildlife Refuge.

In the early part of the twentieth century, an island existed between Horn and Ship islands that was known as Dog Keys or the Isle of Capri. A gambling casino was constructed there, and regular ferries transported the customers from the mainland. The entire island had disappeared by the early 1930s. Today the

site is recognized as a shallow area, a reminder of the evanescence of all barrier islands.

I first camped on Horn Island in the spring of 1939, along with most of my small high school class. Then there were whole days we could walk its beaches and watch the ospreys wheeling about their conspicuous treetop nests or plunging into the waters offshore to catch a fish. We never got to both ends of the island since one was nearly ten miles from where we had camped. The quartz sand above the high tide mark was blindingly white and relatively coarse. It often made a squeaking noise when one walked on it. Some of the dunes were higher than twenty feet. During our stay of several days we saw no one on the island besides the members of our group. Subsequent trips to Horn Island were infrequent, and World War II, medical school, and Korean War duty resulted in a decade without a visit to the islands. After 1953, I began making increasingly frequent trips in a new sloop that my uncle had built. The destination was often Horn Island where the beaches, forest, and lagoons remained as beautiful and deserted as ever. There the urgencies and cares of the world seemed remote. If there were other human footprints on the beach they often were those of Walter Anderson, an artist from Ocean Springs, but I rarely saw him.

By the end of the 1950s, I was married and had an outboard boat that would take me to Horn Island within thirty minutes of launching at Ocean Springs. I began going to Horn Island, often alone and often more than weekly, carrying a camera to record interesting finds or the landscape or birds, animals, and plants. Occasionally I went on east to Petit Bois. It had few trees, all clustered closer to the eastern end of the island, and there were numerous central lagoons in which, as on Horn, there were alligators. But it took nearly an hour to reach Petit Bois and its vegetation and fauna were essentially the same as those of Horn Island, so Horn received most of my attention. My wife considered me to be obsessed and often said so, though she enjoyed time on the island, as did my two small children. We often stayed much longer than planned, and on one such occasion my uncle sent the Coast Guard to search for us. I have painful memories of a low-flying airplane parachuting a note onto the dunes instructing me to nod my head if my name was Bradburn and to wave my arms if I needed assistance.

During the two decades following World War II the number of small boats on the Gulf Coast increased dramatically. Though most of those that came out as far as Horn Island stayed offshore to fish, it became clear to me that pressures on the islands might ultimately be devastating. I heard vague rumors of a proposal to build a causeway to the barrier islands. Then, on a birding trip with friends in the spring of 1969, one of them remarked, "I see where they're trying to make your island into something like a national park." The remark deeply disturbed me. The island was already a wildlife refuge. It could hardly be improved. There were already thirty miles of mainland beach easily available for the usual beach recreation. Despite Horn Island's history of humans' past use, the forces of nature had effaced those changes and returned it to an untrammeled place similar to that found by Bienville in 1699.

In mid-1968 I had received a call from ex-marine and lawyer J. William Futrell asking that I join in organizing a local chapter of the Sierra Club. A nucleus of a dozen or so individuals then undertook to establish such a group. The Sierra Club, initially a small California-based outdoors hiking and conservation club founded by John Muir in 1892, was a main participant in the fight to keep dams from being built in the Dinosaur National Monument in the early 1950s, a fight that attracted national attention, crystallized the postwar conservation movement, and catapulted the small Sierra Club to a position of national prominence.

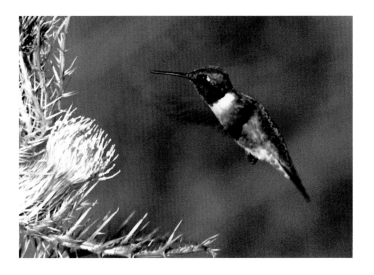

Conservationists, having won this landmark battle to preserve the wilderness in a national monument, now began the long campaign for legislation that would guarantee permanent wilderness preservation for specific areas of federal lands. This culminated in the passage of the Wilderness Act of 1964. Though this act is a milestone in the wilderness preservation movement and a cornerstone in guaranteeing continuous wilderness qualities of so-designated federal lands, its passage necessitated serious compromises. It set aside relatively little wilderness initially and required congressional action on all subsequent additions, preceded by a complicated process of identification and review of potential areas by the agencies of the Department of Agriculture and the Department of the Interior. The act requires the area proposed to be "untrammeled," that is, essentially free of the effects of humans, and once so qualified the proposal is subject to a public hearing, at which time the public can voice approval. Assuming there is a favorable response, a bill must be introduced and passed by Congress designating the area as wilderness. Such a designation does not exclude human activities so long as these activities are not associated with permanent change.

In the 1960s there were efforts to protect several striking areas from development by placing them in a new category, the National Seashores, under the jurisdiction of the National Park Service, Point Reyes and Cape Cod being examples.

In response to an inquiry from our local Sierra Club in 1968, the club's Washington office disclosed that a bill by Representatives Colmer, Sikes, Hebert, and Dickinson to establish a Gulf Islands National Seashore designed to include the Chandeleur Islands in Louisiana, Cat, Ship, Horn, and Petit Bois islands in Mississippi, Ono Island and Perdido Key in Alabama and Florida, and much of Santa Rosa Island, as well as other sites in Florida, had been introduced and died in the Ninetieth Congress. Hearings had been held in Washington, Biloxi, and Pensacola. Statements made by attendees in Biloxi all favored the proposal, save for that of Nathan Boddie, owner of Cat island. No one in Biloxi spoke out for preservation of the existing qualities of the islands, but in Pensacola two professors from Florida State University made a short statement for the Sierra Club supporting the National Seashore concept, regretting the proposed removal of Horn and Petit Bois from the National Wildlife Refuge system, and urging the National Park Service to manage those islands with regard to their wildlife and wilderness values.

By the time that I became aware of this it was late March 1969. In response to my inquiries, Congressman F. Edward Hebert wrote that the bill would soon be introduced in substantially the same form in the Ninety-first Congress. He also forwarded the agency studies that had been carried out at the Interior Committee's request. Here, I read of the National Park Service's vision of "almost unlimited opportunities for camping, picnicking . . . water skiing, boating, bicycling, hiking, and bird watching." Chillingly, they foresaw an eventual 10 million annual visits.

I felt a growing concern for Horn and Petit Bois, especially Horn with its osprey population. I wrote the National Audubon Society, alerting them to the problem and recommending the islands' retention as a wildlife refuge. In answer to a similar letter, Leslie Glasgow, formerly of LSU and, at the time, assistant secretary of the Department of the Interior in Washington, wrote that the islands were to be managed so as to afford maximum protection to wildlife values. To support this view he forwarded the portion of the proposed general management plan for Mississippi. Here, I noted a boat-docking area and camping and picnicking facilities for Horn Island. Planned for Cat Island were an airstrip, marina, concession stands, hunting areas, lodgings, a visitor contact station, and more.

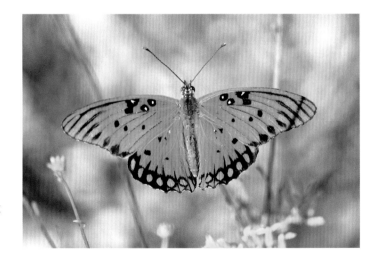

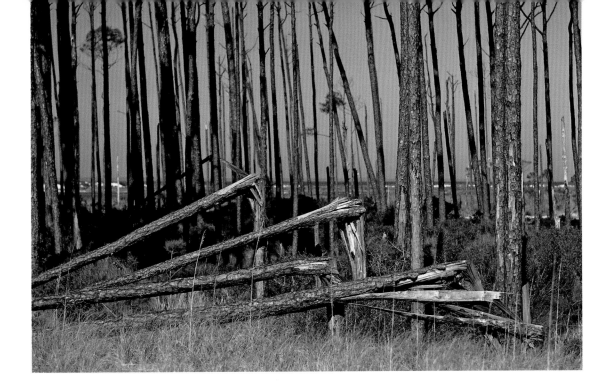

In August 1969 Hurricane Camille wrecked the Mississippi Gulf Coast. It devastated the docking facilities of the U.S. Fish and Wildlife Service refuge at Point Cadet in Biloxi. Their small ranger station on Horn Island withstood the storm, but, with a damaged boat and ruined mainland facilities, the service did not return to patrol Horn and Petit Bois.

By the fall of 1969 the Sierra Club group in New Orleans had begun regular monthly meetings. With a bill introduced in Congress to establish a Gulf Islands National Seashore, Bill Futrell, the local club's first chairman, suggested I do an illustrated program on the Gulf Islands. To that end I began sorting through twenty years of color slides and on a September Sunday evening gave such a slide talk to an audience of about fifty people.

Others in the audience must have found my slide show interesting as I was asked to repeat it for the local chapter of the Louisiana Engineering Society and for the Rotary Club of Pascagoula, Mississippi.

A significant event of this fall of 1969 was the local public hearing in New Orleans on a proposal to place the Chandeleur Islands of the Breton National Wildlife Refuge under the protection of the Wilderness Act. Arriving a day or two before the hearing of November 12 was Ernest M. Dickerman, the eastern field representative of the Wilderness Society, an entity with headquarters in Washington, D.C. He met with several of the local conservationists to discuss the imminent hearing, learn the local sentiment and possible misconceptions about the Wilderness Act, and to assess the local conservation movement. He proved to be a quiet, soft-spoken man, originally from Tennessee, who knew the politics, bureaucratic highways and byways, and the legal technicalities related to wilderness designation and management. In the years to come, I was frequently cheered by his characteristic singsong answer to the telephone. "Dickerman," he would announce.

During his short visit to New Orleans, I cornered him one evening to discuss the Gulf Islands. He was obliged to see my slides, afterwards suggesting that we might ultimately place Horn and Petit Bois in the National Wilderness System. Dickerman put me in touch with George Thatcher in Gulfport, Mississippi, who was then publishing several local weekly newspapers, and George subsequently proved to be a great help.

Local Sierra Club members agreed on a strategy to support the Gulf Islands National Seashore Bill with an emphasis on achieving wilderness designation for Horn and Petit Bois islands. Such a designation would require the National Park Service to manage these islands as wilderness in perpetuity.

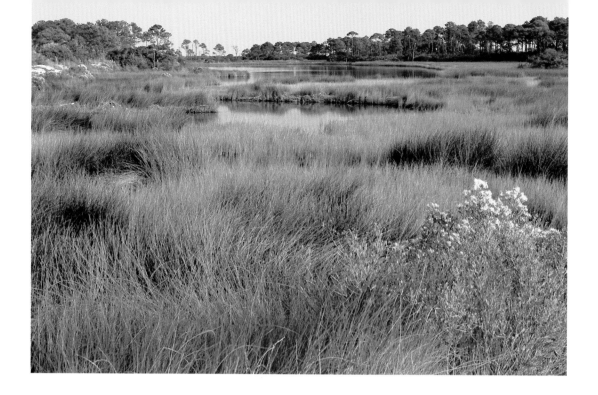

Wilderness designation would prevent any development or man-made changes in these beautiful islands but would not exclude people, who could continue to visit, camp out, fish, and enjoy all the nondestructive uses that characterized most of the human activity that had occurred since the end of World War II. It turned out that Horn and Petit Bois {and also probably Cat Island) were the only white quartz sand, forested islands in the central gulf between peninsular Florida and west Texas, and, despite the fact that there were thirty miles of sand beach on the adjacent mainland coast, no one was suggesting that two relatively small islands (five thousand acres) filled with wildlife should be spared human "improvements." I thought that everyone needed the opportunity of seeing and feeling the land as it was before our forebears arrived, providing a benchmark against which to measure the changes that are called progress as well as the solace of solitude in a beautiful land- and seascape. To this end, we wrote the national Sierra Club's conservation department expressing concern about the changes that the National Park Service was proposing for Horn and Petit Bois and our dismay at the discussion of boatels, hovercraft transportation, and all the other atrocities proposed for Cat Island.

When hearings on the National Seashore bill (H.R. 10874) were announced for June of 1970, I added my name to those wishing to make a statement. By June, support for wilderness designation for Horn and Petit Bois islands had been gained from local groups representing fifteen thousand members in addition to the national Sierra Club's ninety-five thousand. We sent fliers describing the unique attributes of Horn and Petit Bois to members of all the other local conservation groups. Ernie Dickerman produced a flier of similar content which the Wilderness Society mailed to its members. We suggested direct wilderness designation which would circumvent the long, arduous, and tedious process that had been forced into the Wilderness Act and would set a valuable precedent.

At the congressional hearing the Department of the Interior recommended deletion of the Chandeleur Islands and proposed federal acquisition of mineral rights. The owner of Cat Island opposed his island's acquisition by the government. Representative William Colmer of Mississippi, within whose jurisdiction the islands lay, opposed the loss of private mineral rights. The president of the Jackson County Board of Supervisors, wherein lay Horn and Petit Bois, complained that Horn Island had less development planned for it than did Cat Island. He proposed setting aside five hundred acres of Horn as a refuge for birds, animals, and bird watchers and using the rest for "recreation." When asked by Interior Committee members what he meant

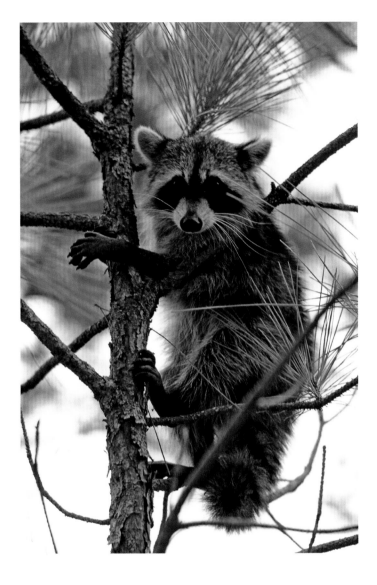

After the hearing, Ernie Dickerman and I visited Congressman Colmer's office and spoke with his administrative assistant, Trent Lott. A young, personable man, Lott seemed interested in what we had to say and was in possession of a Sierra Club newsletter concerning Horn and Petit Bois. It was soon evident, though, that there was a misconception in that office concerning wilderness designation. They seemed surprised to find that we were not opposing the bill and that wilderness designation would not preclude management by the National Park Service or prevent fishing, boating, swimming, hiking, camping, and other nondestructive uses. Trent Lott, being from Pascagoula, was familiar with Horn and Petit Bois.

I visited the offices of the two Mississippi senators, Stennis and Eastland, finding the former knowledgeable in regards to the Wilderness Act but not the latter. In discussions with Senator Eastland's assistants, an older man's comment was that he didn't want the islands "locked up," while a younger man countered that enough development and neon lights already existed on the mainland. It always seemed odd to me that although William Colmer, the prime author of the National Seashore bill, had stated that he hoped the islands would remain in as natural a state as possible, he never came to support wilderness designation. It may have been a generational thing as evidenced by the differing opinions in Senator Eastland's office. I visited the offices of Louisiana senators Long and Ellender, where I was able to evoke little interest, but Louisiana congressman Hale Boggs met with me for about half an hour, looked at my photographs, and told me of his familiarity with the Mississippi islands and how his ancestors had once owned Cat Island. He promised to help.

By October of 1970, H.R. 10874 had passed the House and been sent to the Senate with Cat Island, lands in Alabama, and the Chandeleur Islands in Louisiana deleted, shifting more pressure to Horn. That summer, George Thatcher devoted the entire front page of the *Dixie Guide*, a monthly news magazine of Mississippi, to an article on the Mississippi barrier islands; it consisted, in large part, of the statement I had made to the House Interior Committee and my photographs. Rapid action, predicted in the Senate, did not materialize, and in early December 1970 we learned, from the Sierra Club's Washington representative,

by recreation he suggested "Atlantic City" and "boardwalks" as what he had in mind. I argued for direct placement of Horn and Petit Bois into wilderness. Wayne Aspinall, the chairman of the House Interior Committee, opined that a clause directing the National Park Service to review lands for possible wilderness designation within a designated time after establishment of the National Seashore could accomplish the same purpose without bypassing the many hurdles imposed by the Wilderness Act and that more or less ended our attempts at direct designation.

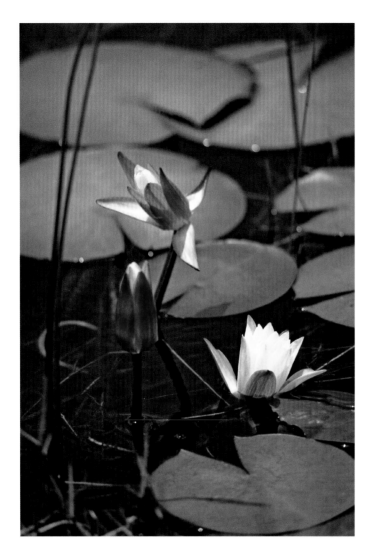

Islands National Seashore. The bill included a section that directed review within four years of lands within the National Seashore to determine suitability for wilderness designation. Any such designation was to be in accordance with the provisions of the Wilderness Act.

The newspapers of the day published maps of the National Seashore complete with the National Park Service's proposed management plans, including, on Horn Island, boat-docking areas, beach and fishing access areas, and camping and picnicking facilities.

In response to an invitation to the local Sierra Club to provide a window display at the main public library in New Orleans, we mounted several large panels of text and photographs depicting wilderness in the Gulf Islands and the need for its preservation. At George Thatcher's instigation it was displayed subsequently in the Gulfport public library. The Gulf Coast newspapers in 1971 had frequent items concerning the National Seashore, reporting the acquisition of a headquarters site at Mississippi's Magnolia State Park in Ocean Springs and later the naming of an advisory committee for the National Seashore.

The pathway to wilderness designation in the Gulf Islands now was as follows: (1) the National Park Service was required to assess what areas qualified for wilderness designation and to make a plan which would then be the subject of a hearing, at which time the public could comment on this proposal, agreeing with it or suggesting modifications and alternative plans; (2) following the public hearing, the secretary of the Department of the Interior was to make a final recommendation which could serve as the basis for legislative action; a bill designating wilderness would be required; (3) until studies and a proposal were made, the National Park Service was required not to alter the wilderness qualities of areas that might qualify for designation; (4) after the public hearing on a proposal by the National Park Service there would be no administrative mechanism for public input.

If wilderness designation was to be achieved for Horn and Petit Bois it was obvious that abundant local advocates would be necessary, and in sufficient numbers to warrant strong political support. No one else active as a conservationist possessed an intimate familiarity with Horn and Petit Bois or had illustrative

of an impasse due to objections of the governor and the state Mineral Lease Commission to the exclusion of mineral exploration within the proposed boundaries of the National Seashore. George Thatcher seemed confident that he could reach someone of influence.

On Monday, December 14, the headlines of the New Orleans *Times-Picayune* reported a compromise in which the National Seashore boundaries in Mississippi were narrowed. The compromise measure passed the Senate, and on January 8, 1971, Richard Nixon signed Public Law 91-660, establishing the Gulf

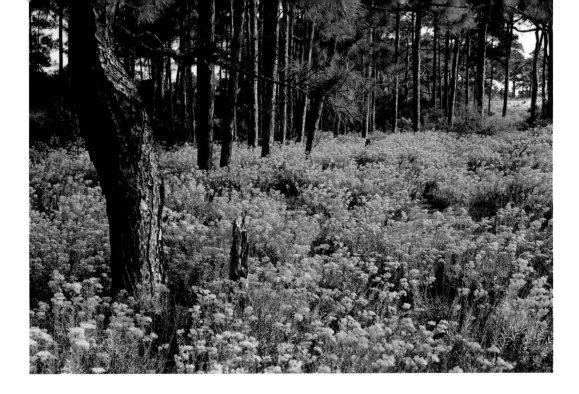

material in any depth. I felt compelled to defend the values that these islands embodied and that I loved so much. I feared the personal devastation awaiting me if my efforts failed. I responded to more and any invitations from garden clubs, women's clubs, churches, the DAR, Rotary clubs, etc., to give my free illustrated talk. Theo Harvey of Harvey Press printed large color posters with one of my photos of Horn Island titled "The Last Wilderness," advocating wilderness designation. I presented a black and white photo exhibit and gave my color slide talk on Horn and Petit Bois at the 12th Wilderness Conference in Washington, D.C. In November 1971 my black and white photos of the Mississippi Islands were exhibited at Studio 8, a local art gallery.

Richard Stokes was the first superintendent of the western (Mississippi) portion of the National Seashore. He was wiry, tall, and grey-haired and had previously been assigned to Everglades National Park. It was said that he had had a big hand in the Everglades wilderness proposal of more than 1 million acres. I came to know Dick Stokes fairly well. We spent considerable time discussing National Seashore and conservation matters as well as hiking on Horn Island. Dick was adamant in his feeling that wilderness designation was inappropriate for the Gulf Islands. I don't remember his reason for it other than they were too small. I came to the conclusion that, like his agency's, his

views reflected use tailored to expeditious management. In the National Park Service visitors are encouraged and counted. The larger their number, the bigger the requested budget and the more prestigious the position. Thinking smaller doesn't come naturally to the successful administrator, even if the resource demands it. The National Park Service at that time, of all the pertinent government agencies, maintained the poorest record of review and wilderness designation of lands under its jurisdiction.

Stokes began to give talks to local groups and was quoted by the newspapers describing development plans, including those for Horn and Petit Bois, which reflected the management plan made prior to passage of the enabling act. His mention of the wilderness review clause was either not made or not quoted, a situation that placed him and the National Park Service in a position of de facto support of development. There seemed to be no stopping him directly, and so we wrote letters of complaint to the director of the park service and higher officials. This allayed the situation somewhat. Local interest in the fate of the islands continued, provoking numerous requests for my illustrated talk. My strategy was to illustrate the islands' beauty and wildlife, contrasting Horn and Petit Bois with the crowded fishing piers, trailer camps, and concessions that stood in or just outside of the Florida segment of the National Seashore and to suggest that

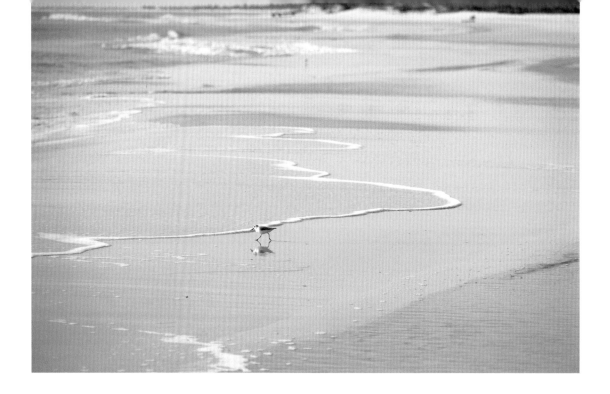

wilderness designation was the most effective means of preserving Mississippi's unique and beautiful islands. At the conclusion of each presentation I requested that willing listeners enter their names and addresses in a notebook if they would help by writing a letter in support of a meaningful wilderness designation at the time of the public hearing on the matter. I promised not to bother them in the meantime and only notify them when the time came. I had photo exhibits at the Edgewater Mall near Biloxi and in Picayune, Pascagoula, Ocean Springs, and Pass Christian, all in Mississippi, which spread the message and sparked additional publicity. Cable TV in Biloxi did a program in connection with the Edgewater Mall exhibit that emphasized the islands' wilderness features. The *Dixie Roto* magazine of the *Times-Picayune* devoted the cover and two pages of color photos and text to Horn Island wilderness in 1972. I came to know many of the environmental reporters and the editors of newspapers on the Gulf Coast and in New Orleans and took those who were interested to Horn Island. This was usually a convincing experience.

By mid-1974 I had talked to groups from Lafayette, Louisiana, to Pensacola, Florida, and from Biloxi to Jackson in Mississippi. As more Sierra Club groups and other conservation organizations sprang into existence in Louisiana and Mississippi, they took up the call and spread the word. After talking to more than forty-five groups, I had acquired hundreds of names and addresses of sympathetic individuals who were outside of the traditional conservation movement.

In January 1974, *Audubon* magazine published an article illustrated by my photos and written by John Madson, whom they had sent to camp on Horn Island. In his piece Madson wrote, "It's hard to understand how this place could possibly be improved by any sort of development. Of all the island treasures off the Gulf Coast, Horn is regarded as the crown jewel." And in 1974 *The Horn Island Logs of Walter Inglis Anderson* was published, a testimony to the sort of inspiration that such a place could provide.

Fall came and there was no word of the National Park Service's wilderness review and proposal, which the law required before January 8, 1975. New Orleans's public broadcasting station, WYES-TV, suggested a program on Horn Island using my color slides, a script by Les Brumfield, environmental and outdoors editor of the New Orleans *States-Item*, original music by Milton Scheuerman, Jr., and narration by Julian Sherrouse. Production was begun in September.

In mid-October the National Park Service announced its proposal for wilderness and set public hearing dates as

December 2 and 3 in Biloxi and Pensacola (the National Sea-shore was divided into western [Mississippi] and eastern [Florida] divisions headquartered in Ocean Springs and Pensacola, respectively). As I had long feared, the park service's proposal made a mockery of the intentions of the Wilderness Act. Essentially it patched "wilderness" around the park service's previously conceived management plan. On Horn Island it proposed to leave out all of the beaches and exclude two fifty-foot cross island corridors and one hundred acres near the center of the island where there were a ranger station and campground, as well as an area of dunes and trees on the north shore that bordered a lagoon, which they proposed dredging for a small boat harbor. The corridors were to be partly paved and were for the use of motorized vehicles provided for ranger patrol and beach cleanup. There was a ferry boat dock on the north beach near the ranger station. According to the National Park Service, "Intensive recreational use of the beaches, beach campgrounds and management activities associated with recreation use, such as necessary beach patrol and cleanup, render the beaches unsuitable for wilderness designation." On Petit Bois, the beaches were similarly excluded as was a cross island corridor. A passenger ferry dock and two campgrounds were proposed.

Two small wilderness islands without their beaches! A miracle of National Park Service double talk! Moreover, the plan proposed to add the extensive private holdings, yet to be acquired, only at the discretion of the secretary of the Department of the Interior. The plan was simply unbelievable. Our hope now was to confront the park service with public outrage and political disapproval. Trent Lott now represented the Fifth Congressional District in Mississippi, in which the islands lay, having been elected as a Republican following Democrat William Colmer's retirement. Lott seemed to have some sympathy for wilderness, but carefully avoided any commitments. After the park service's plan had been announced I wrote him, pointing out its inadequacies and inconsistencies, but he would only say that he was preparing his statement for the hearing. It was clear that an alternate plan for Gulf Islands wilderness was needed.

The "Citizens' Wilderness Proposal" was written by Ernie Dickerman and me. Its wilderness included essentially all of Horn and Petit Bois islands as well as the surrounding water bottoms, excluding only two acres for the ranger station on Horn Island. Privately held land was to be included automatically upon acquisition. Including the water bottoms would prevent docks (which would attract big boats carrying large numbers of people), and the small exclusion for the ranger station would not be sufficient for a campground situated foolishly in the sweltering, insect-infested interior of the island. Hearing alerts were

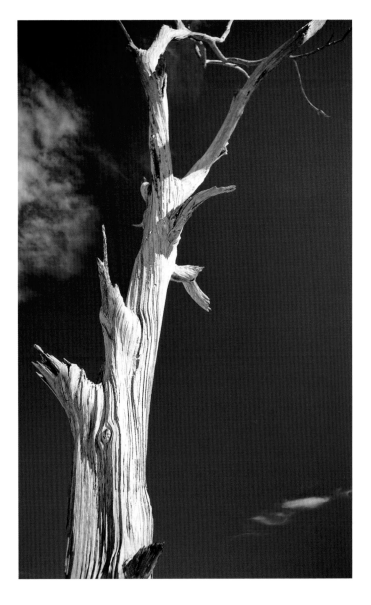

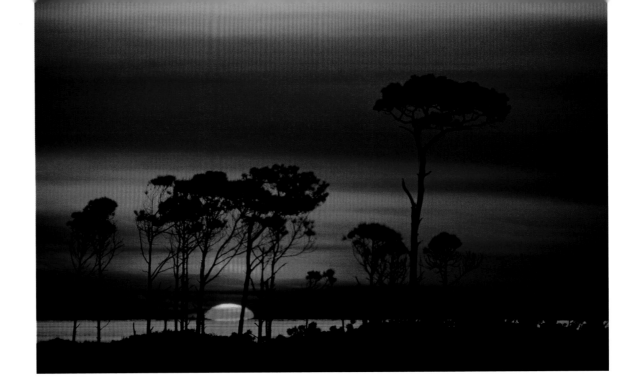

prepared which described the islands, outlined the Citizens' Wilderness Proposal, and pointed out the National Park Service plan's gross deficiencies.

The announced hearing became increasingly newsworthy. "Save Our Last Wildlife Area" headlined the *Mississippi Sun*'s editorial of November 22 in support of total wilderness. An editorial in the New Orleans *States-Item* supported total wilderness. The Mississippi coast *Daily Herald* headlined an article with "Park Service Plan for Islands Shocking, Conservationist Claims." "Horn and Petit Bois Islands Called Diamonds to Be Made into Rhinestones" headed an article in the *Times-Picayune*. Richard Stokes as spokesman for the National Park Service was quoted as saying that motorboats as well as privies would be excluded by wilderness. A park service document stated that sport fishing and motorboat use over submerged lands designated as wilderness would be prohibited. It was not clear whether these erroneous statements stemmed from ignorance or design. Their repetition became a significant confusing factor in the support of the Citizens' Wilderness Proposal. Sympathetic articles appeared in the Jackson, Mississippi, *Clarion-Ledger*. The Mississippi Wildlife Federation, Mississippi Audubon societies, and the Sierra Club groups were all publicizing and gaining support for the Citizens' Wilderness Proposal. The Wilderness Society

made a national mailing to their members of the hearing alert in support of the Citizens' Wilderness Proposal. Mimeographed alerts were sent to the hundreds of people who had signed up at more than half a hundred slide shows. The station WYES-TV hurried to complete their program. "The Fragile Barrier," a half-hour program on Horn Island wilderness, was first shown on November 27 at 9:00 p.m. It was shown again on Mississippi PBS. It subsequently won a national PBS honorable mention, the first such honor for WYES.

The evening before the Biloxi hearings a large group of wilderness advocates assembled in my place in Ocean Springs to plan coordination of their statements, and my floors were filled with sleepers who would be the following morning's speakers. The next morning when I reached the Biloxi Community Center, site of the public hearings, the auditorium was filled. Prominently situated in the audience sat a man with large sandwich-board signs over his shoulders proclaiming, "Oh, wilderness were paradise enow." The hearing began, as I recall, with a spokesman for the National Park Service, followed by other governmental and local officials, and it was soon apparent that all opposed any commercial development (the *Mississippi Sun* said they were in "violent agreement"). Former congressman William Colmer made a statement strongly in favor of the park service

proposal, as were statements from the Jackson County Board of Supervisors, a motel owners' association, and several individuals. But as the hearings progressed I heard, in growing disbelief and euphoria, the governor, the lieutenant governor, Representative Thad Cochran of the Fourth Congressional District, the Mississippi Game and Fish Commission, the Mississippi Agriculture and Industry Board, state legislators, and the distinct majority of other individuals speak in support of the Citizens' Wilderness Proposal. When state representative Marby Penton claimed that a boat dock was needed on Horn Island so "senior citizens" could visit the island, Verda Horne, who had come to represent the Alabama Conservancy, sprang up, saying, "Here's one old lady who is willing to wade ashore." A condominium developer supported

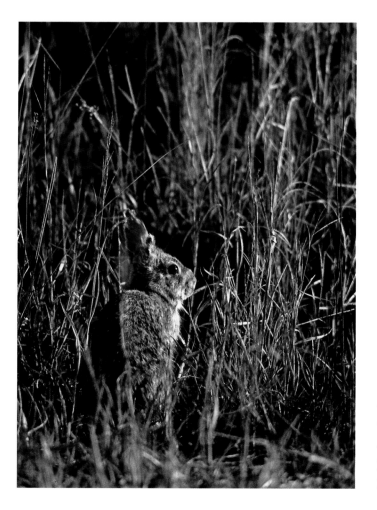

the Citizens' Wilderness Proposal, claiming that the unique resource that it would protect would enhance real estate values in areas nearby. John Anderson, son of Walter the artist, made a particularly appropriate plea for total wilderness to the more than four hundred persons at the hearing. I read a statement for the national Sierra Club, and my wife, Anne, read the statement written by Ernie Dickerman for the Wilderness Society. I confess twinges of sympathy for Dick Stokes, who on this day seemed to represent the villain to many of those present.

That evening was celebrated quietly and exultantly in Walter Anderson's cottage with John Anderson and several others. On the following day we drove to the Pensacola hearing. Wilderness proposed for Mississippi drew fewer attendees, but those who spoke were largely in favor of the Citizens' Wilderness Proposal. Editorials supporting the Citizens' Wilderness Proposal appeared in newspapers from New Orleans to Pensacola. Trent Lott's statement stopped short of supporting either proposal. In answer to the letter that I wrote to him following the hearings, he wrote that he was going to urge the National Park Service to change their plans but expressed concern about docks for taxpayers who didn't have a private boat. There seemed to be no logic in that, since taxpayers who came by a commercial boat could come ashore in the same manner as he and I did without the use of a dock. In fact, in Acadia National Park in Maine, visitors to wilderness Isle au Haut land from a park service boat without the use of a dock, and the superintendent there told me that he thought it enhanced the experience for the majority of visitors.

Another letter from Congressman Lott referred to a meeting with the National Park Service requesting that their proposal be "substantially modified in light of additional study and statements at the hearings." Once, he spoke of legislation coming in the next session of Congress.

Coast newspapers in early January 1975 announced a wilderness compromise, placing all but twenty-four acres of Horn in wilderness and with retention of a small ferry dock on Horn. The compromise proposal was said to have followed a meeting between the Atlanta regional director of the National Park Service and Assistant Secretary of the Department of the Interior Nathaniel Reed. The proposal, if approved by Secretary of the Department of the Interior Rogers Morton, would be forwarded

to President Gerald Ford for submission to Congress. We adamantly opposed a ferry dock because, besides representing an intrusion, it would fix the landing site for ferries bringing larger numbers of visitors to the center of the island instead of permitting more flexible management. There was no further word of the compromise.

In June of 1975 I got an appointment with Assistant Secretary Reed, went to Washington, gave him my illustrated talk, and found him in apparent sympathy with my goals for Horn and Petit Bois. My feeling was that he was seeking to insure meaningful wilderness but was dependent on the National Park Service for most of his information and had difficulty in assessing the need for docks and certain other of the park service's proposals. I was asked for and supplied detailed information concerning Horn and Petit Bois. But nothing else came to fruition, and, when President Carter was elected, the officials and aides that I had come to know were gone.

Trent Lott, when asked in March 1977 to introduce a bill for Horn and Petit Bois wilderness, answered that he looked forward to introducing a bill for Horn and Petit Bois wilderness at "an appropriate time." Subsequently, a modified National Park Service proposal had been forwarded to the Office of Management and Budget (OMB) as required and had not been cleared. The reasons for this did not become clear until the end of the year.

In December, Representative Philip Burton of California was preparing an omnibus bill designed to designate multiple wilderness areas that were pending. By this time Ernie Dickerman had retired, and I spoke with Raye Page of the Wilderness Society. She discovered that OMB had not cleared the proposal because of special language included by the National Park Service that allowed the use of motorized vehicles on beaches included in wilderness, a use that was inconsistent with the Wilderness Act. She indicated that support from Trent Lott could override whatever the park service came up with. She was less than optimistic about the chances for the gimmicky proposal stalled in OMB but suggested letters to Lott and Burton giving reasons for beach inclusion, vehicle exclusion, etc. So I and others sent yet another set of letters. Shortly thereafter, Raye Page had an opportunity to bring the stalled proposal to the attention of the new park service director, who directed his staff to investigate the matter immediately. The Burton bill markup was then about two weeks away. By early May the Burton Omnibus Bill was reported out of the full committee with Horn and Petit Bois included but without their adjacent submerged lands. After a tense and cliff-hanging journey through the last days of the Ninety-fifth Congress, Public Law 95-625, the National Parks and Recreation Act of 1978, became a reality. Among other things, it added 1,854,424 acres of designated wilderness to the National Park System, including Horn and Petit Bois Islands.

PHOTOGRAPHS

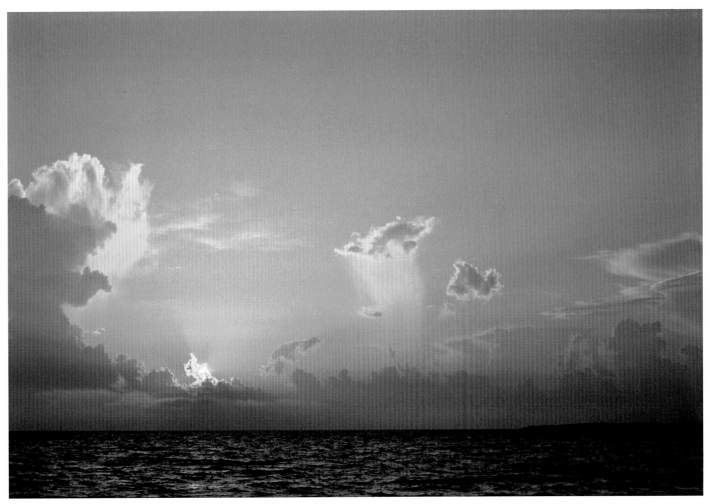

Sunrise over Mississippi Sound. Horn Island, August 1969.

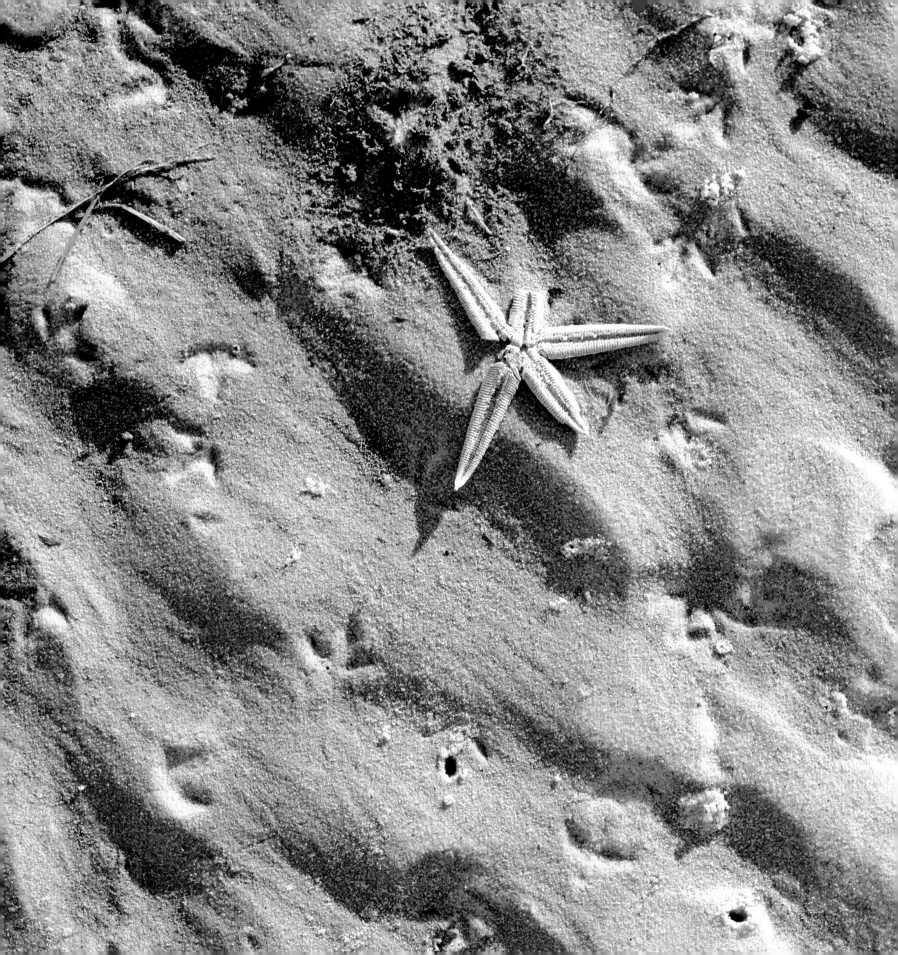

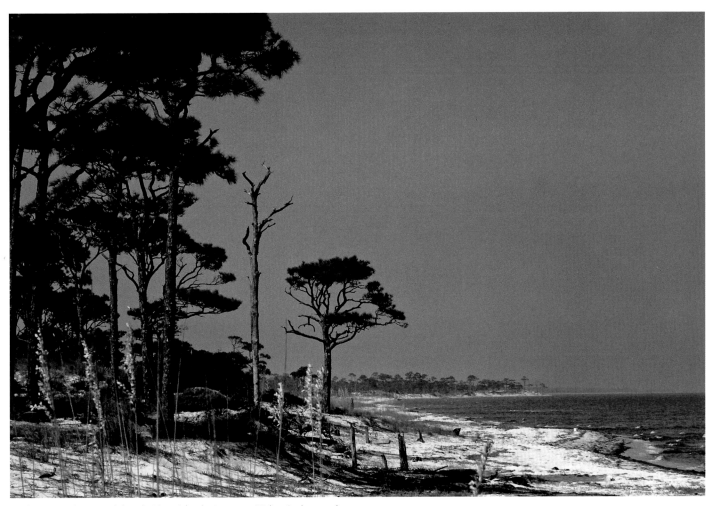

Looking west along north beach. Horn Island, circa 1975. Walter Anderson, the
Ocean Springs artist, often camped in the area of the first peninsula seen.

Opposite: Starfish on beach. Horn Island, March 1987. Dead starfish are more
commonly found near the west end of Petit Bois.

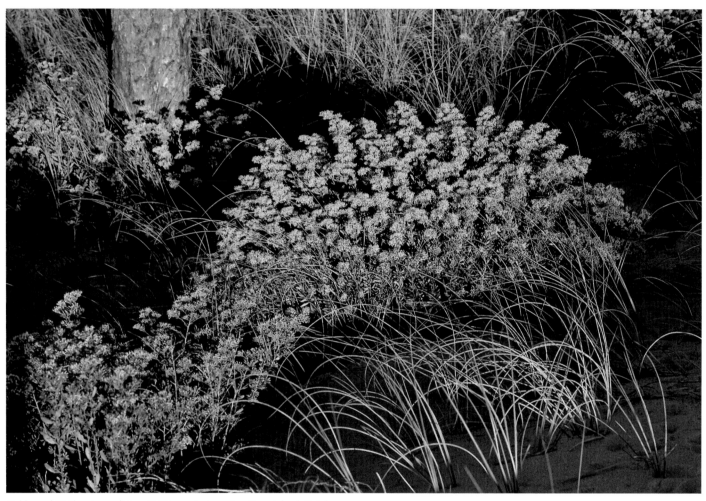

Goldenrod (*Euthamia caroliniana* [L.] Greene) at sunrise. Horn Island, October 1974.

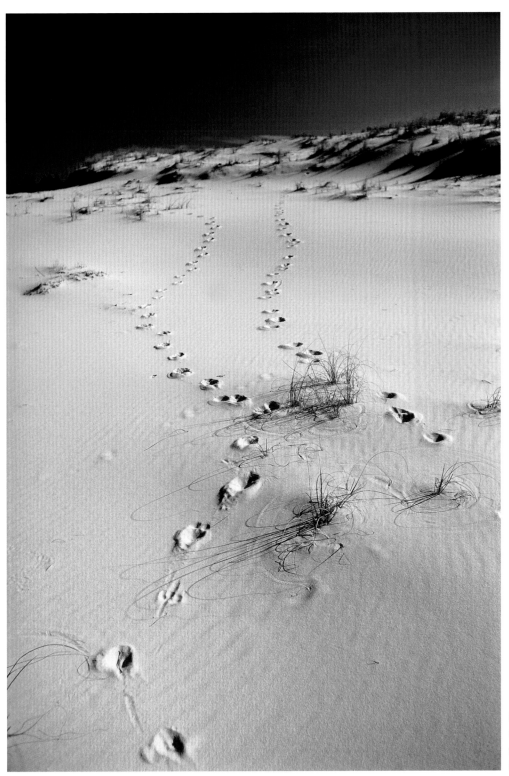

Pig tracks, south beach. Horn Island, March 1970. There were feral pigs on the island which were finally removed after the National Park Service came to control the island.

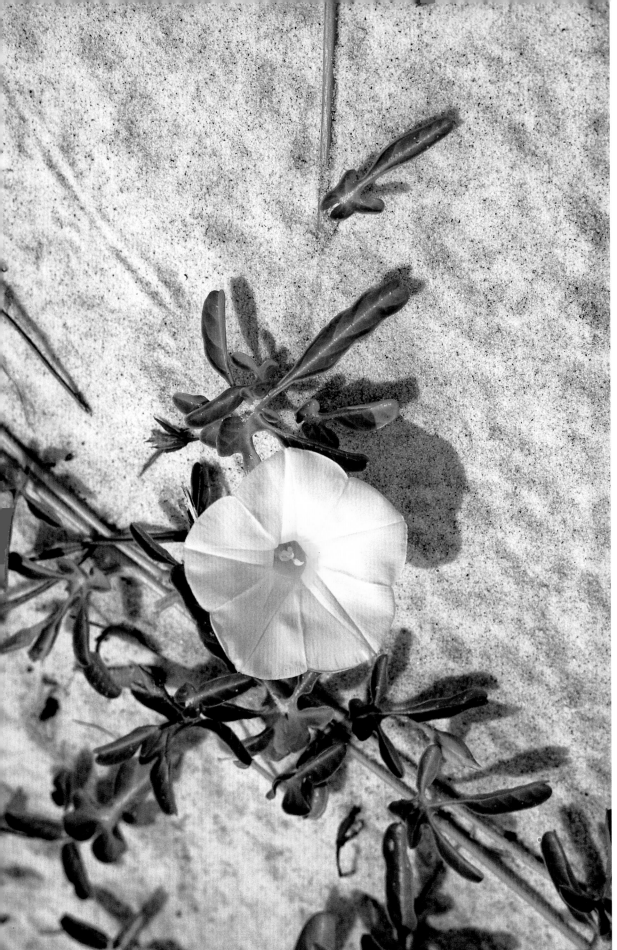

Seaside morning glory (*Ipomea imperati*
[Vahl] Griesb.), north beach.
Horn Island, September 1963.

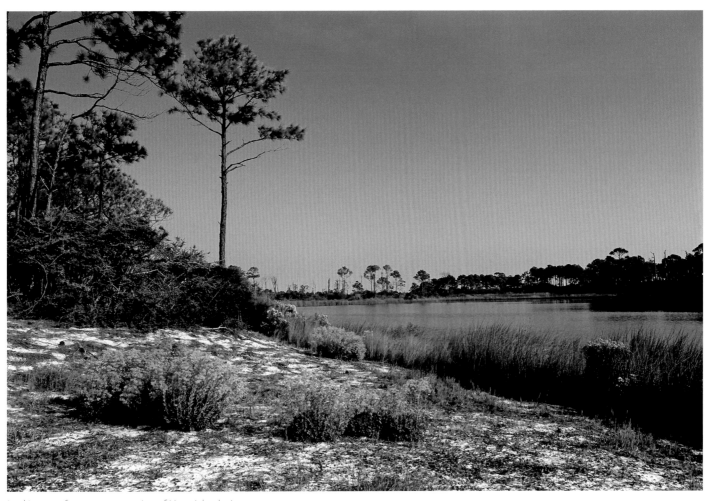

Looking east from western portion of Horn Island, circa 2000.

Goldenrod and rabbit tracks. Horn Island, October 1963.

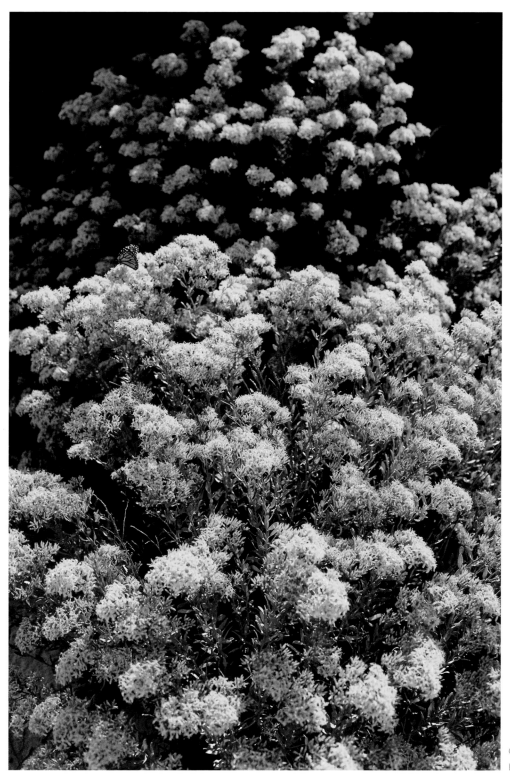

Goldenrod.
Horn Island, October 1974.

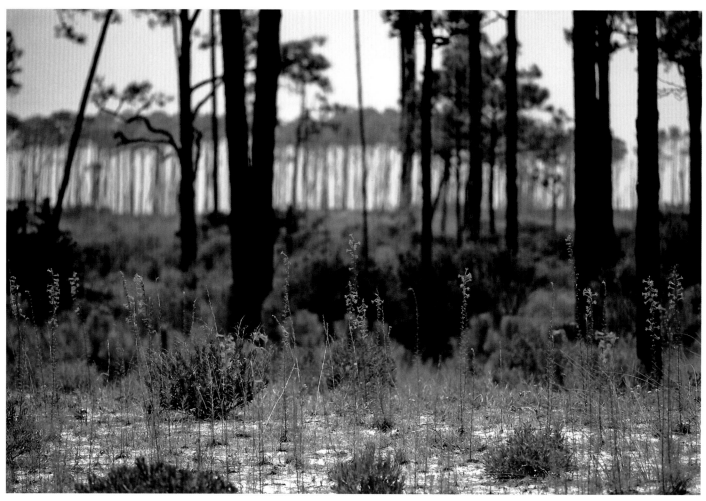

Looking south from near north beach. Horn Island, June 1974.

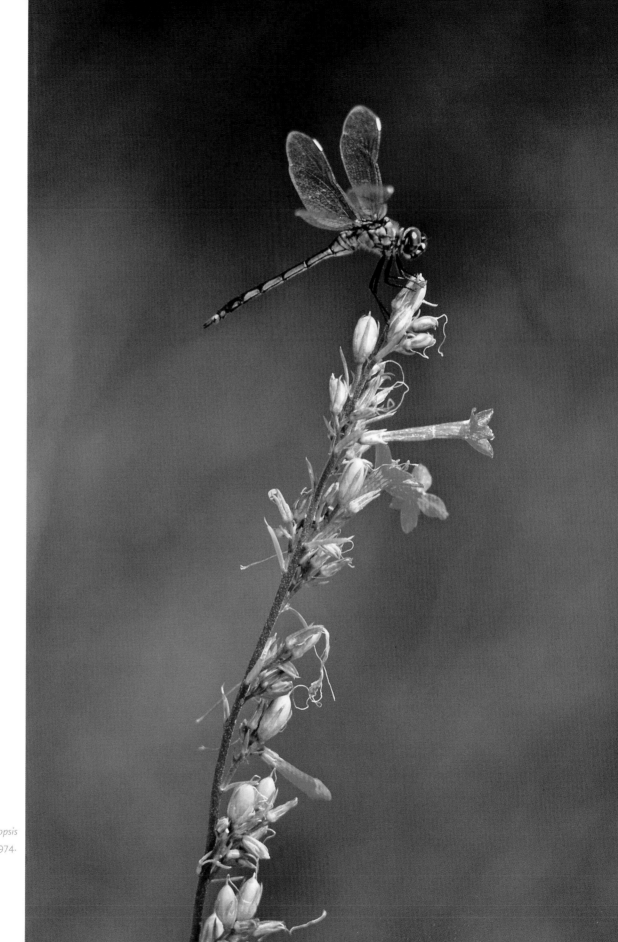

Dragonfly on standing cypress (*Ipomopsis rubra* [L.] Wherry). Horn Island, July 1974.

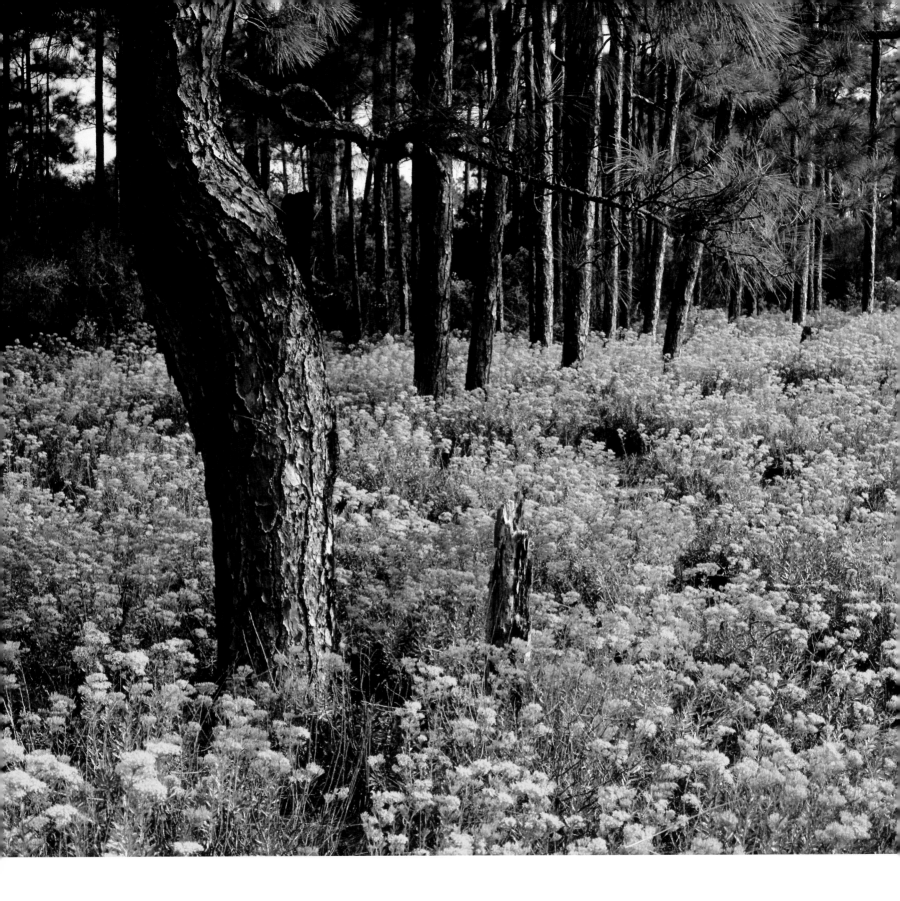

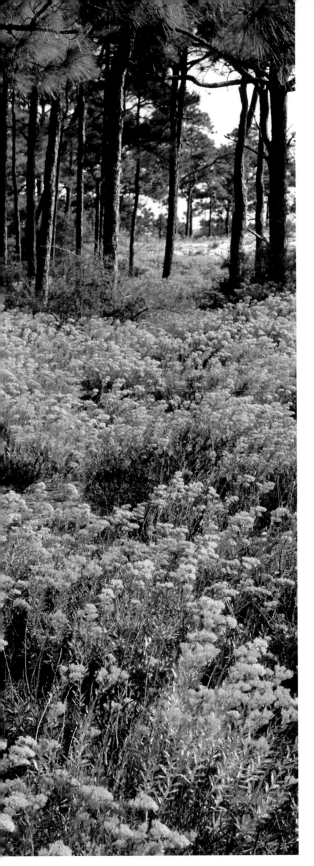

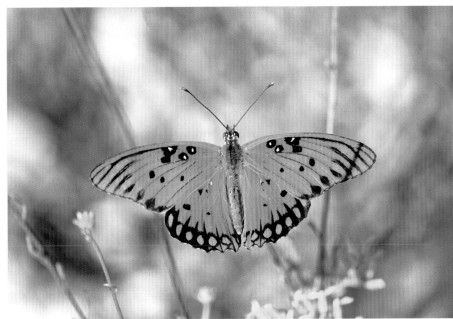

Gulf fritillary (*Agraulis vanillae nigrior*). Horn Island, October 1987.

Opposite: Goldenrod (*Euthamia caroliniana* [L.] Greene) in the island interior.
Horn Island, October 1977.

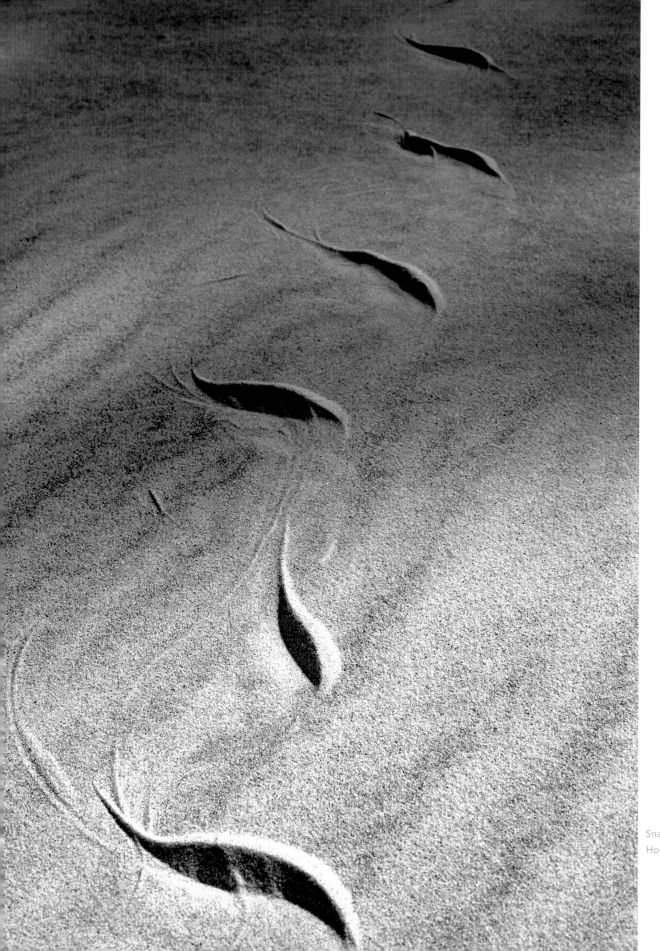

Snake track.
Horn Island, March 1972.

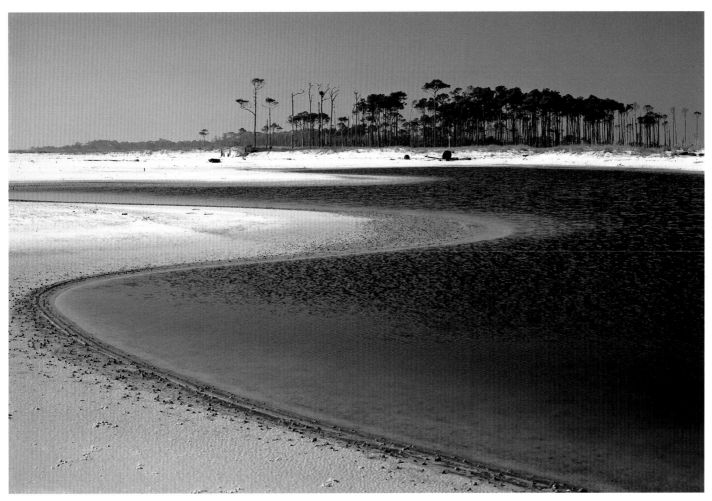

Looking west from near the east end. Horn Island, November 1973.

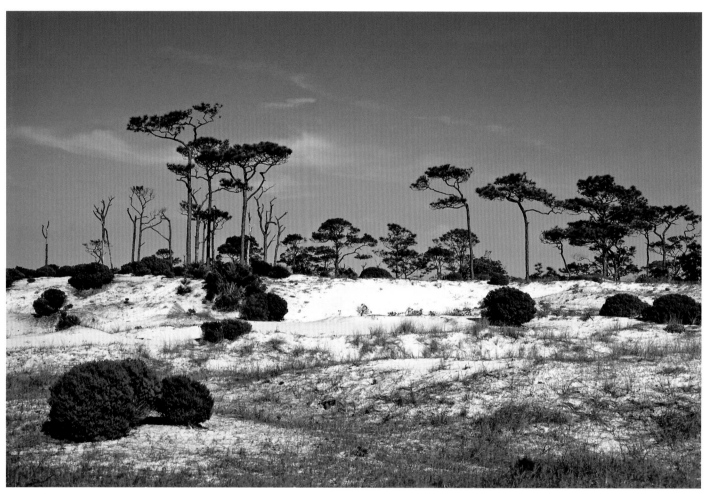

Interior dunes with seaside rosemary (*Ceratiola ericoides* Michx.) and slash pines. Horn Island, February 1974.

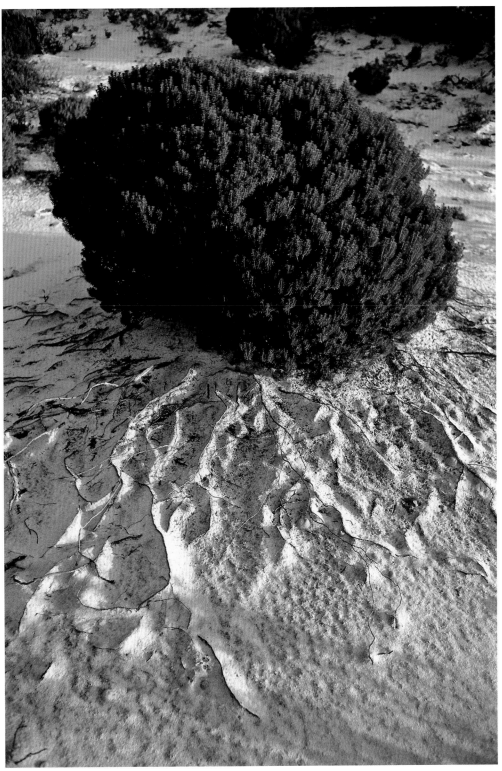

Seaside rosemary. Horn Island, October 1974. This plant has a distinctive, pleasant odor.

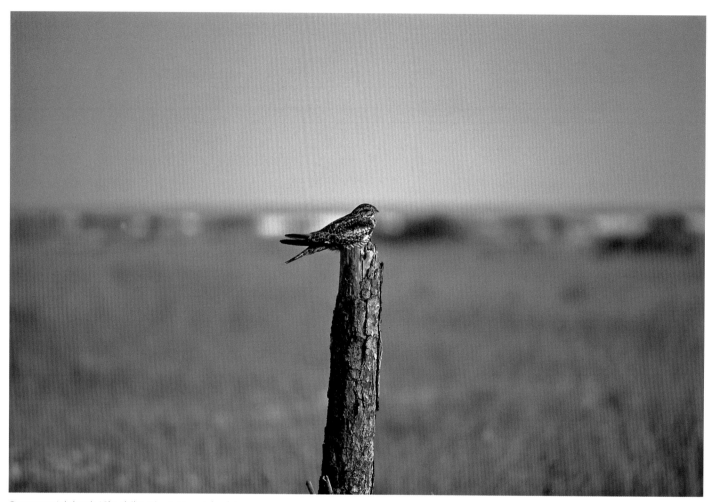

Common nighthawk (*Chordeiles minor*). Horn Island, June 1974.

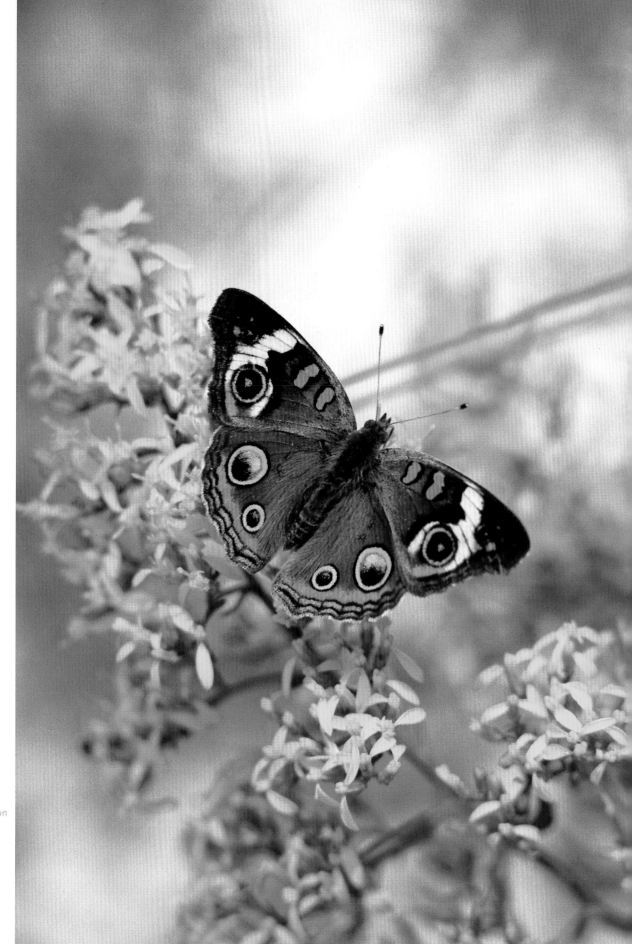

Buckeye butterfly (*Precislavinia coenia*) on goldenrod. Horn Island, October 1977.

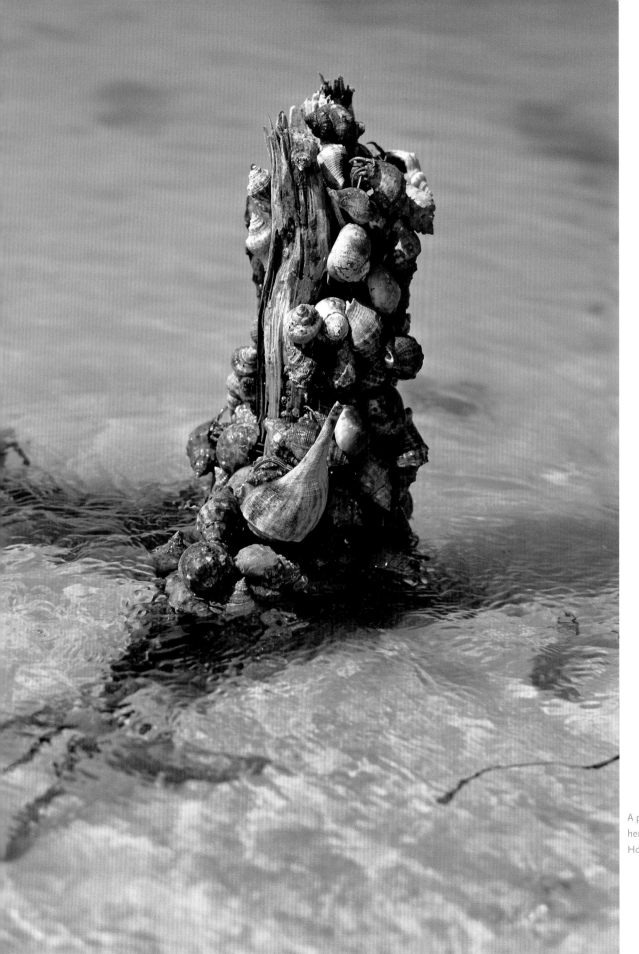

A pine stump provides a respite for
hermit crabs, north beach.
Horn Island, August 1974.

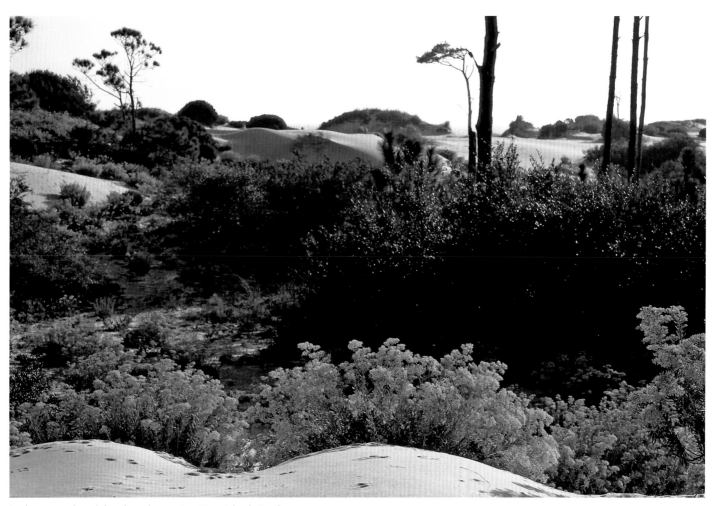

Looking toward north beach, early morning. Horn Island, October 1974.

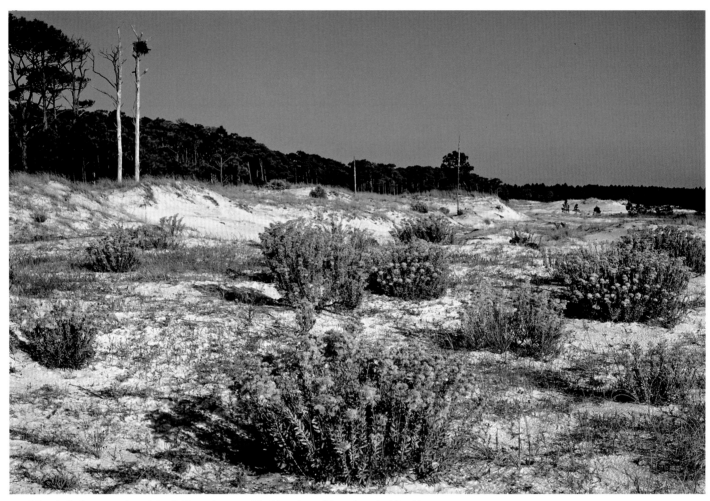

South beach, looking east. Horn Island, November 1973. The blooming goldenrod on the island is spectacular in the late fall. Note the osprey nest in the dead pine.

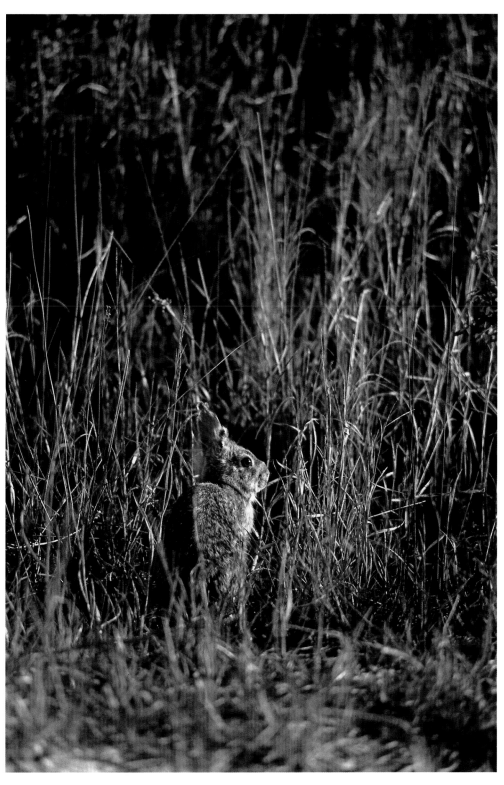

Swamp rabbit (*Sylvilagus aquaticus*).
Horn Island, April 1964.

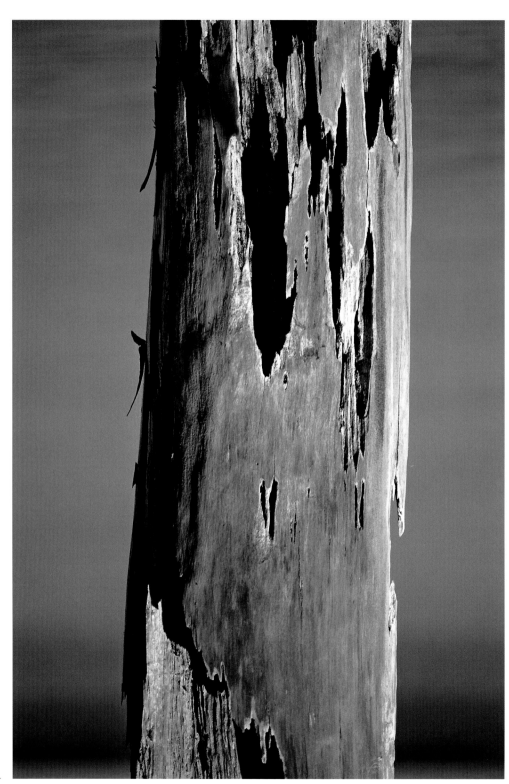

Dead pine, north beach.
Horn Island, September 1974.

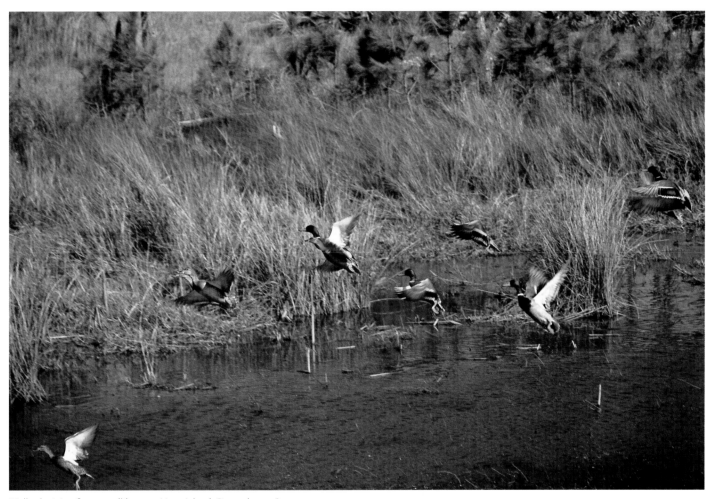

Mallards rising from small lagoon. Horn Island, December 1969.

Dead pine. Horn Island, November 1964. The rough bark has been lost, and the underlying wood has a polished appearance which may in part reflect the work of blowing sand.

Opposite: Snake track in fine sand. Horn Island, March 1967. The snake was ascending the dune.

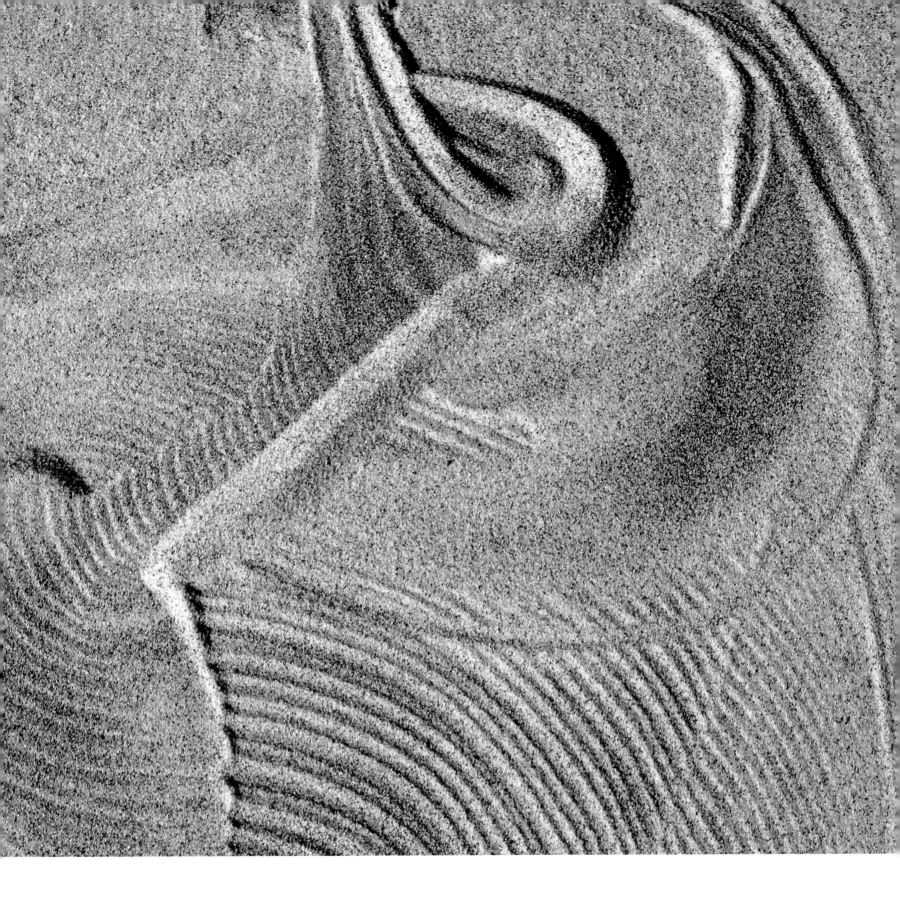

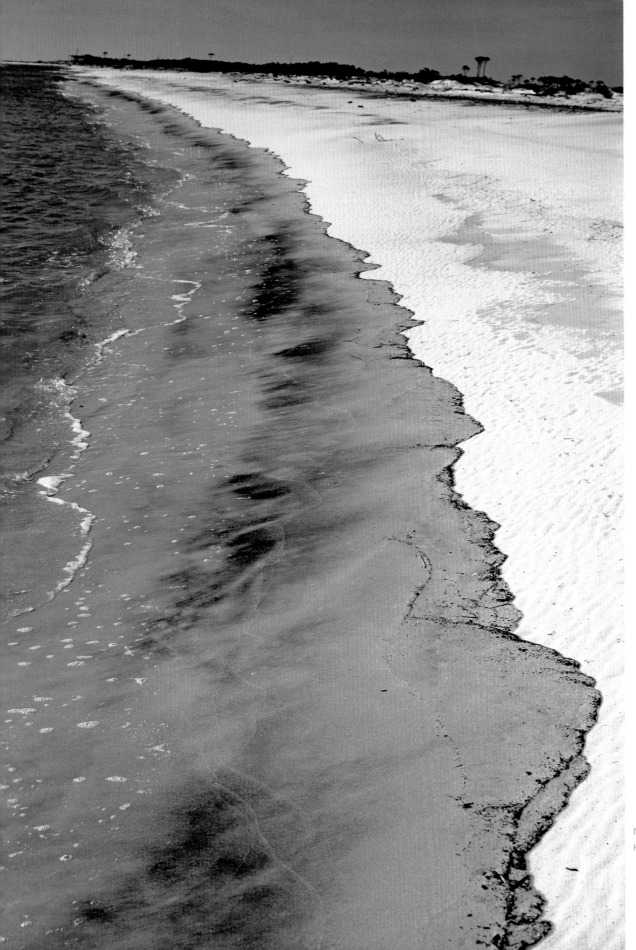

North beach, looking east.
Horn Island, February 1974.

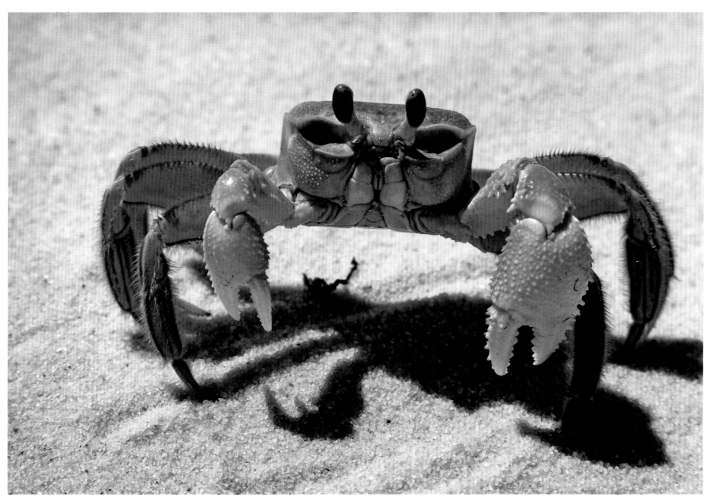

Ghost crab (*Ocypode quadrata*). Horn Island, May 1971.

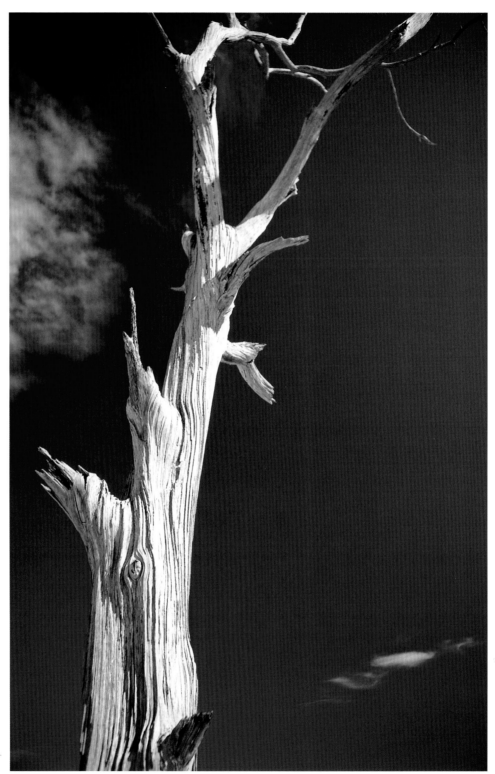

Dead pine near north shore.
Horn Island, October 1971.

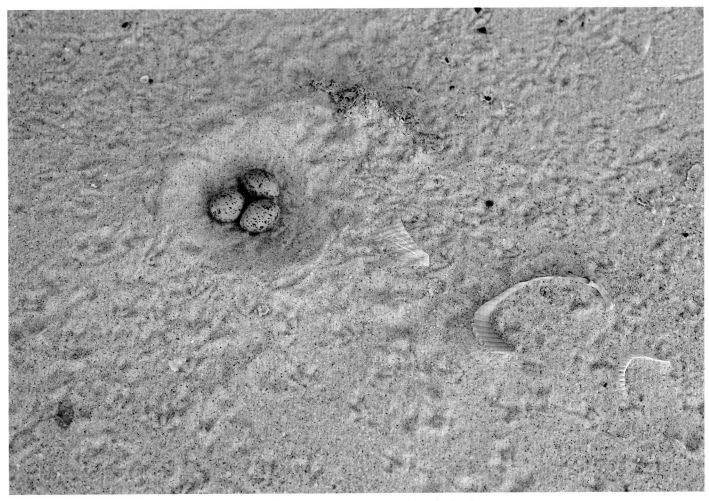

Least tern nest. Horn Island, June 1975. Least terns nest in colonies. Attempts at nesting on Horn Island such as this one on the south beach are usually disrupted by raccoons who eat the eggs.

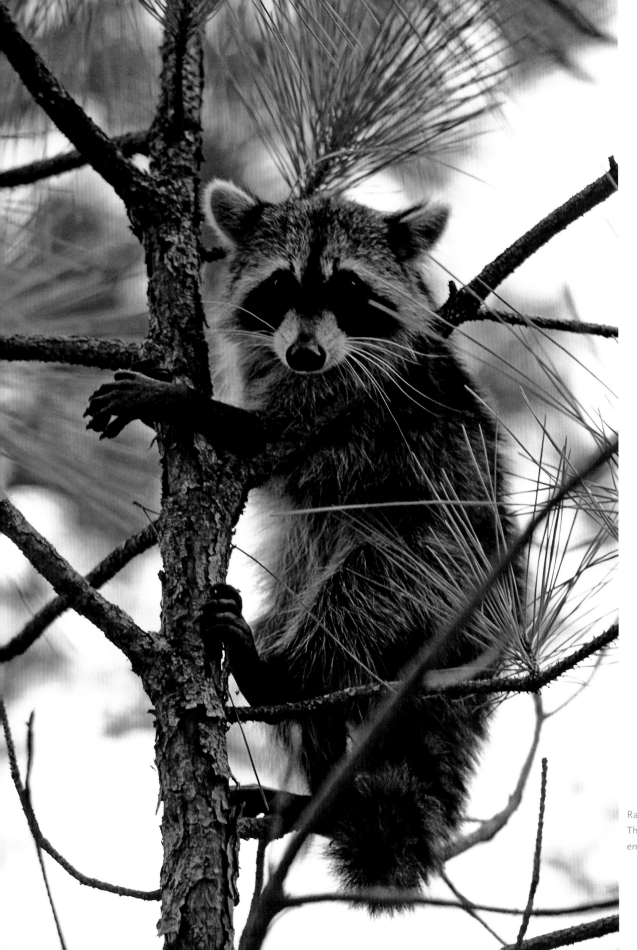

Raccoon. Horn Island, November 1960.
This young fellow made his escape up an
embarrassingly small pine tree.

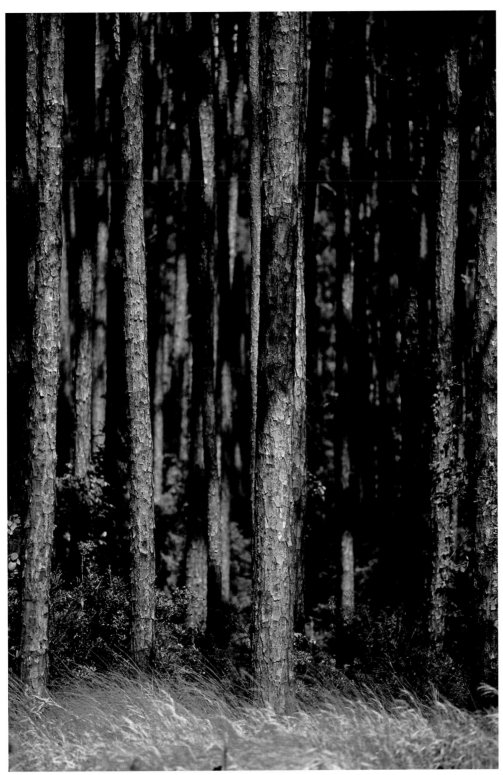

Slash pine forest.
Horn Island, May 1973.

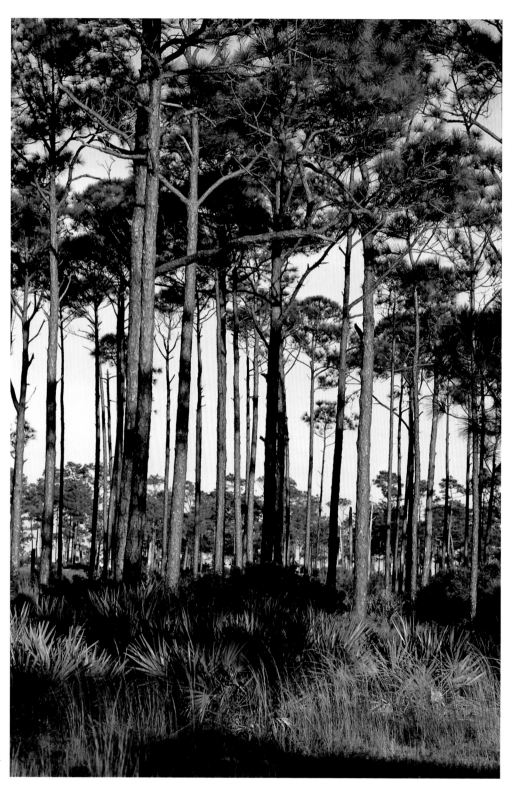

Slash pine (*Pinus elliottii* Engelm.) forest.
Horn Island, January 1973.

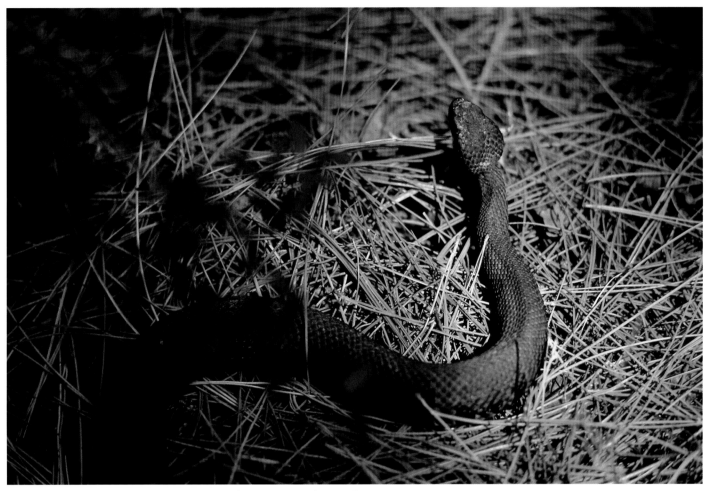

Water moccasin (*Aghistrodon piscivorus*) in slash pine forest. Horn Island, November 1973.

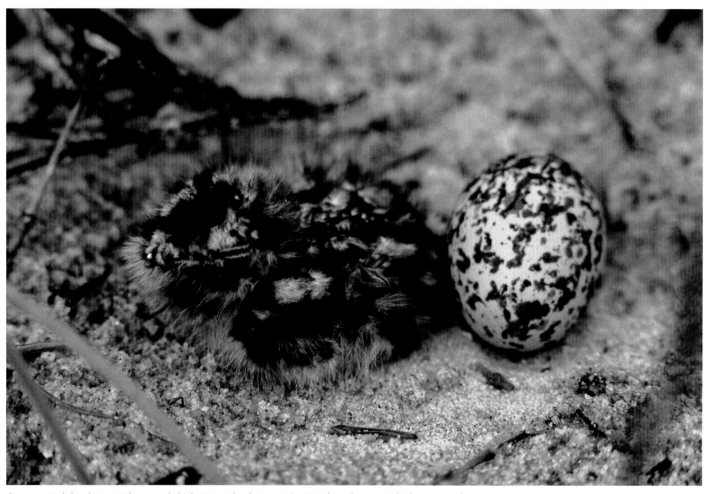

Common nighthawk nest with egg and chick. Horn Island, June 1964. Note how the young chick instinctively closes its shiny black eye which otherwise might compromise its nearly perfect camouflage.

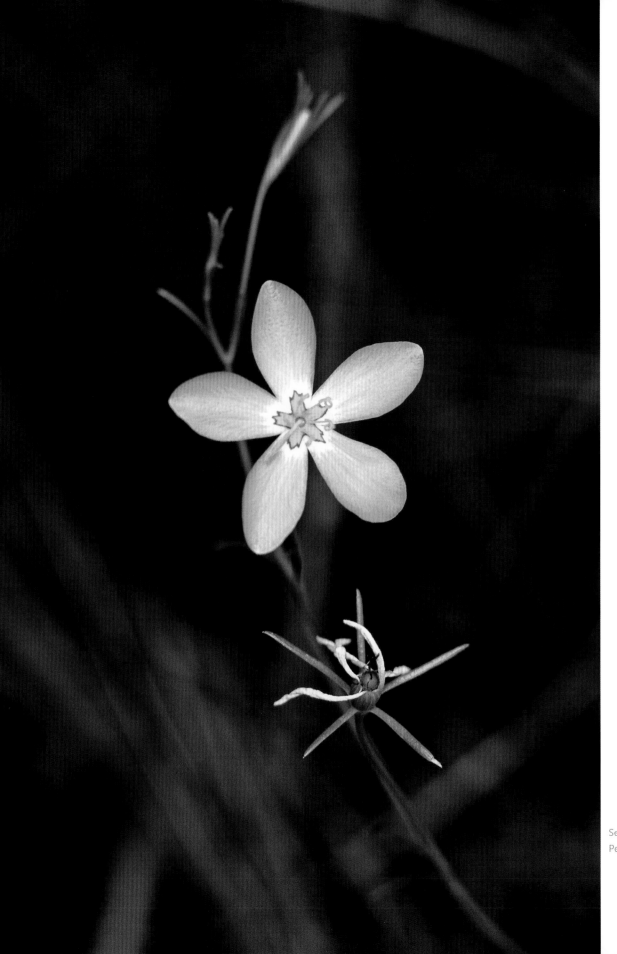

Sea pink (*Sabatia stellaris* Pursh.).
Petit Bois Island, July 1974.

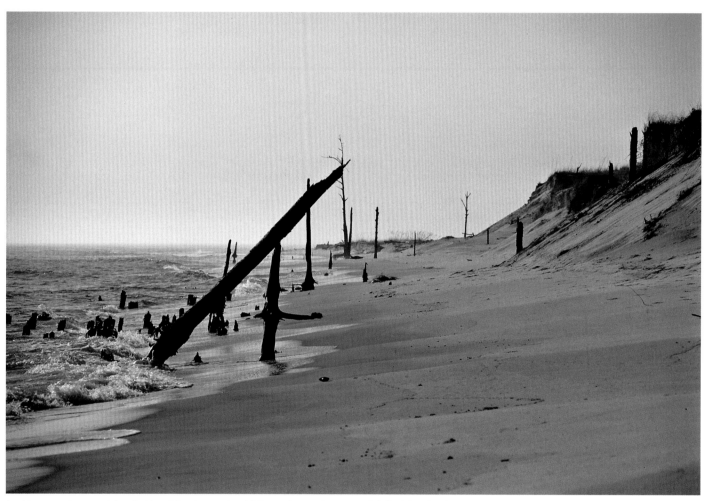

Looking east along north beach. Horn Island, 1970. In addition to the steady westward drift of the island, segments of the shore shift north and south, often leaving parts of the pine forest dead or dying in the shallow water.

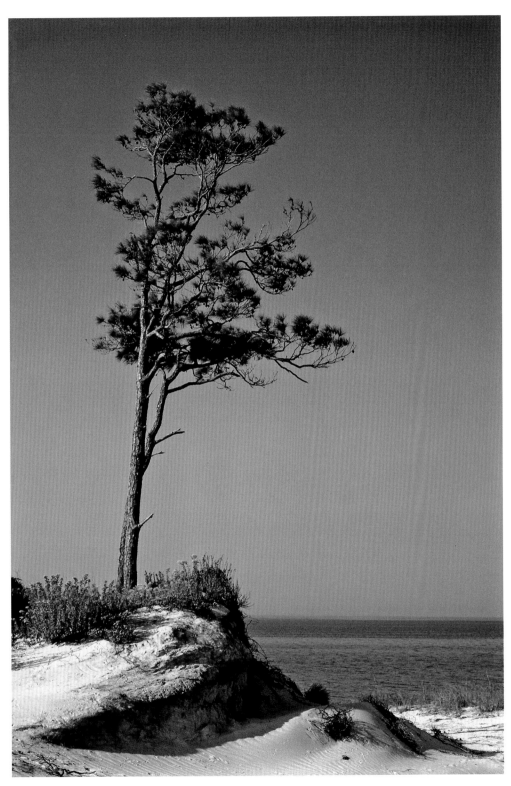

Pine tree, north beach.
Horn Island, October 1974.

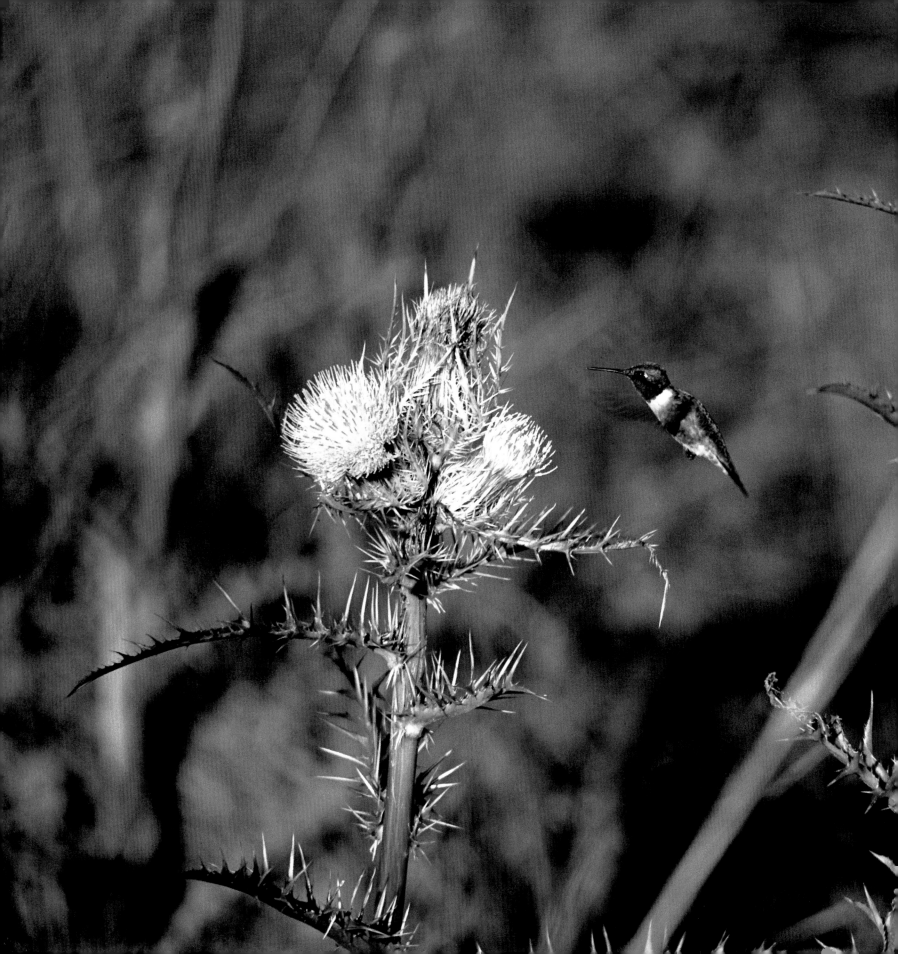

Beach tea (*Croton punctatus* Jacq.) and yucca (*Yucca glorioso* L.).
Horn Island, February 1974.

Opposite: Ruby-throated hummingbird (*Archilochus colubris*) and thistles
(*Cirsium horridulum* L.). Horn Island, May 1964.

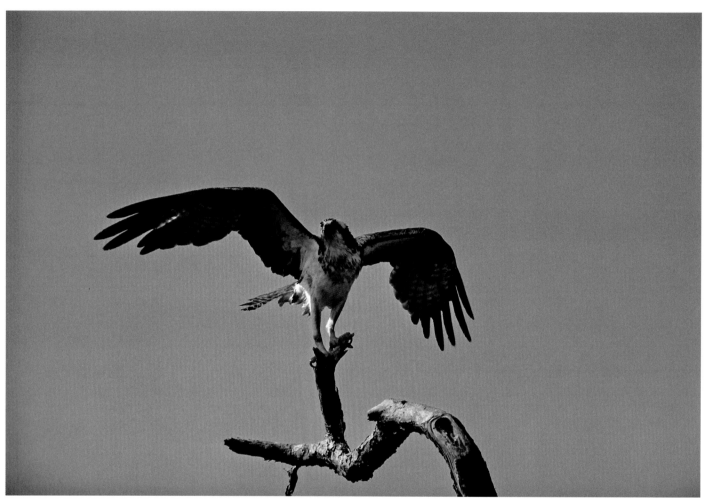

Osprey (*Pandion haliaetus*). Horn Island, June 1973.

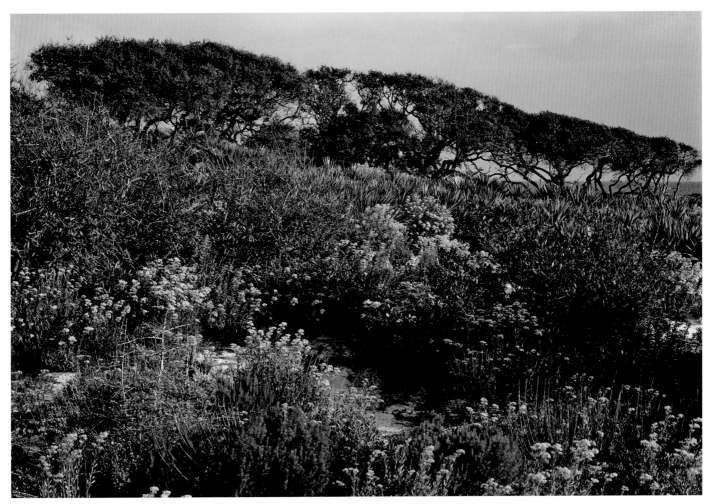

Goldenrod, palmetto (*Serenoa repens* [Bartr.] Small), and live oak near east end of island. Horn Island, October 1978.

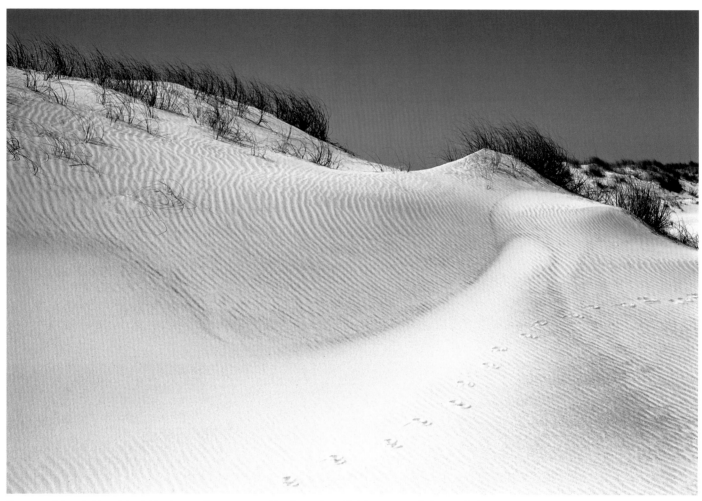

Dune, south beach. Horn Island, March 1974. The quartz sand is often so beautiful that one may feel compelled to detour in order not to destroy nature's artistry.

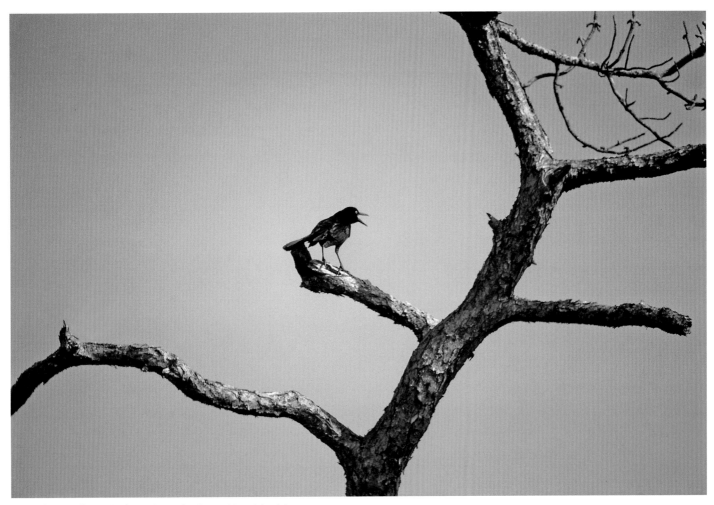

Boat-tailed grackle (*Quiscalus major*) in dead pine. Horn Island, June 1975.

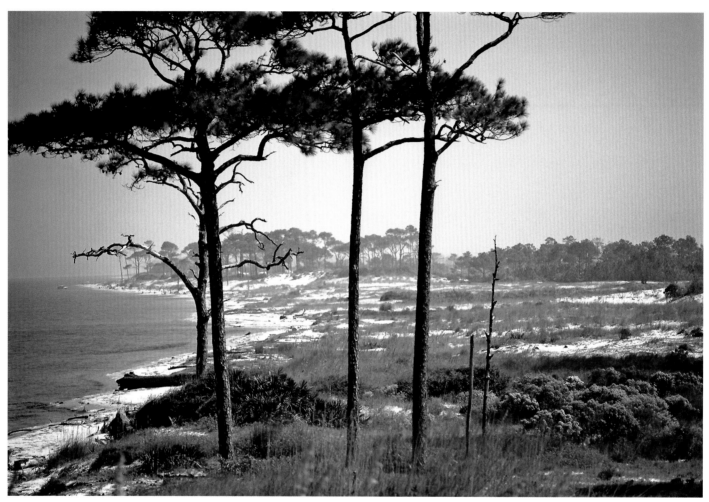

Looking eastward across the gap along the north shore. Horn Island, October 1974.

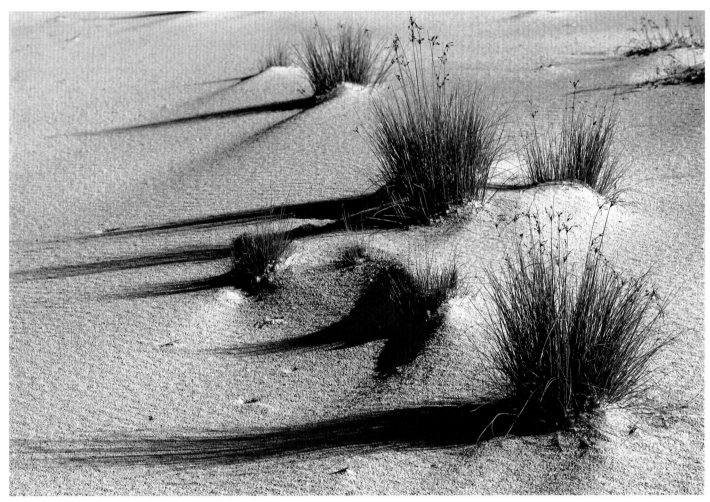

Grass shadows, late afternoon, south beach. Horn Island, December 1974.

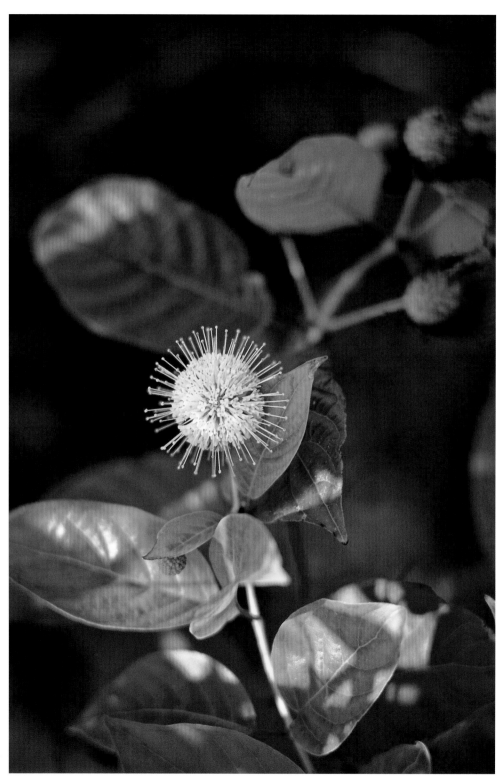

Buttonbush (*Cephalanthus occidentalis* L.).
Horn Island, 1974.

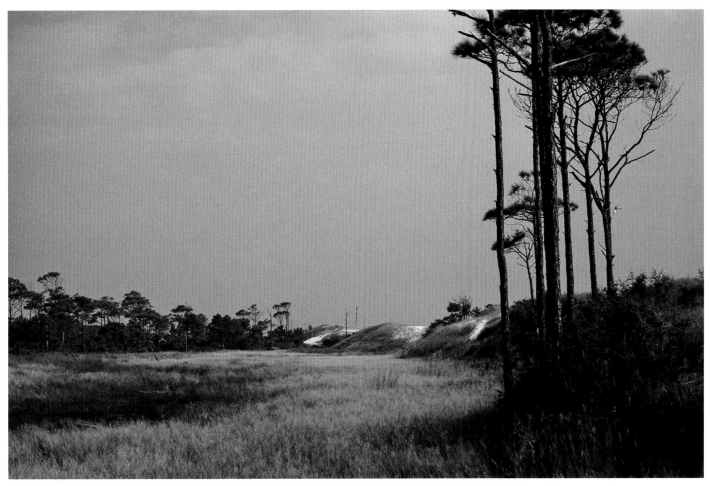

Looking east with marsh interior to large dune separating it from south beach. Horn Island, October 1972.

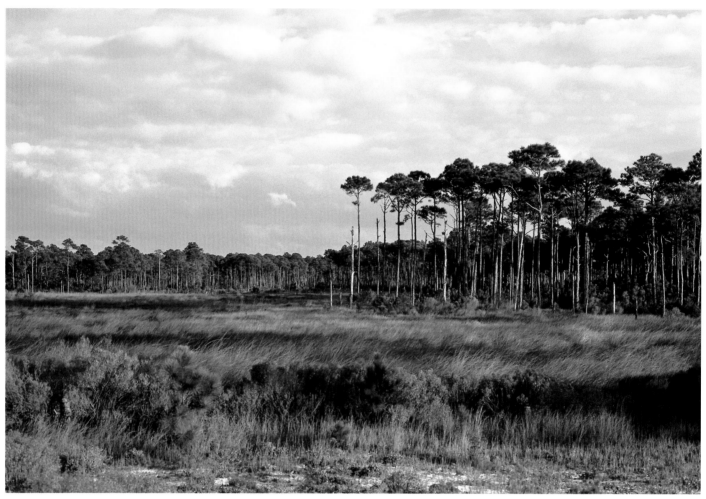

Looking east over interior marsh from near the horseshoe. Horn Island, circa 1970.

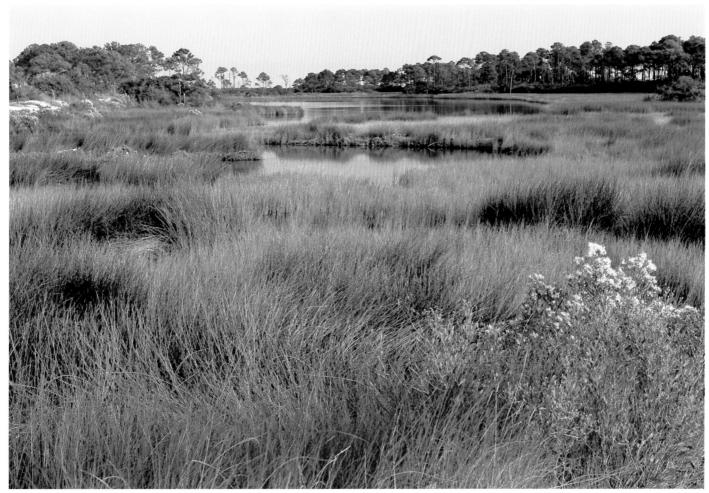

Central marsh and lagoon, looking eastward, west of the chimney. Horn Island, circa 2000.

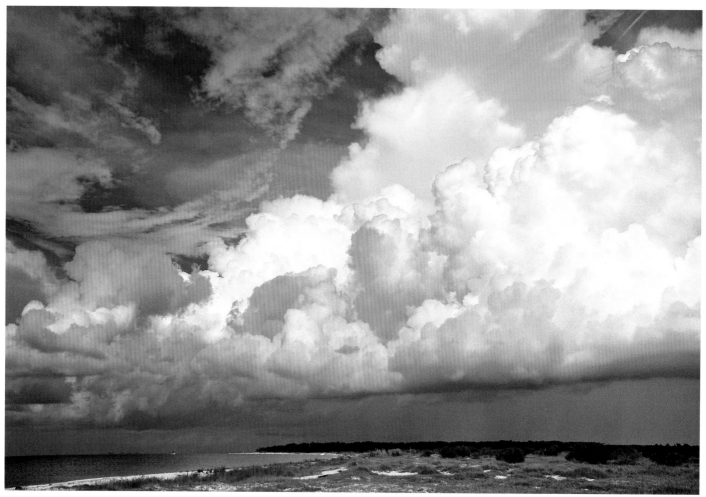

Gathering squall. Horn Island, September 1974. Looking east from beyond the western boundary of the trees.

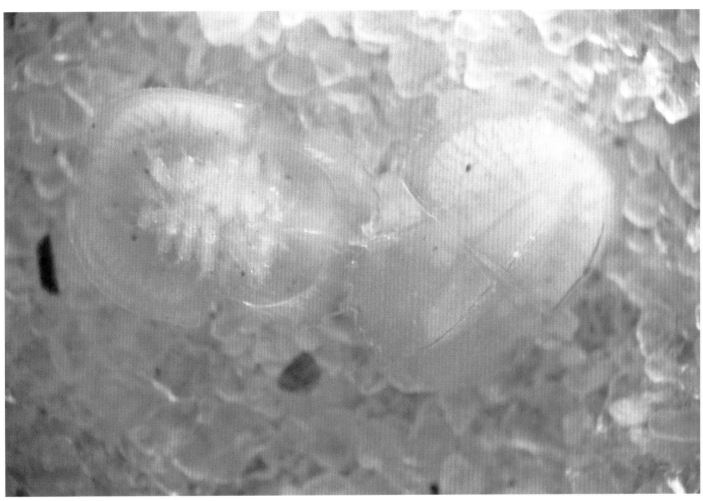

Larval horseshoe crabs, north beach. Horn Island, November 1984. Compare the size of these larvae with that of the included grains of sand.

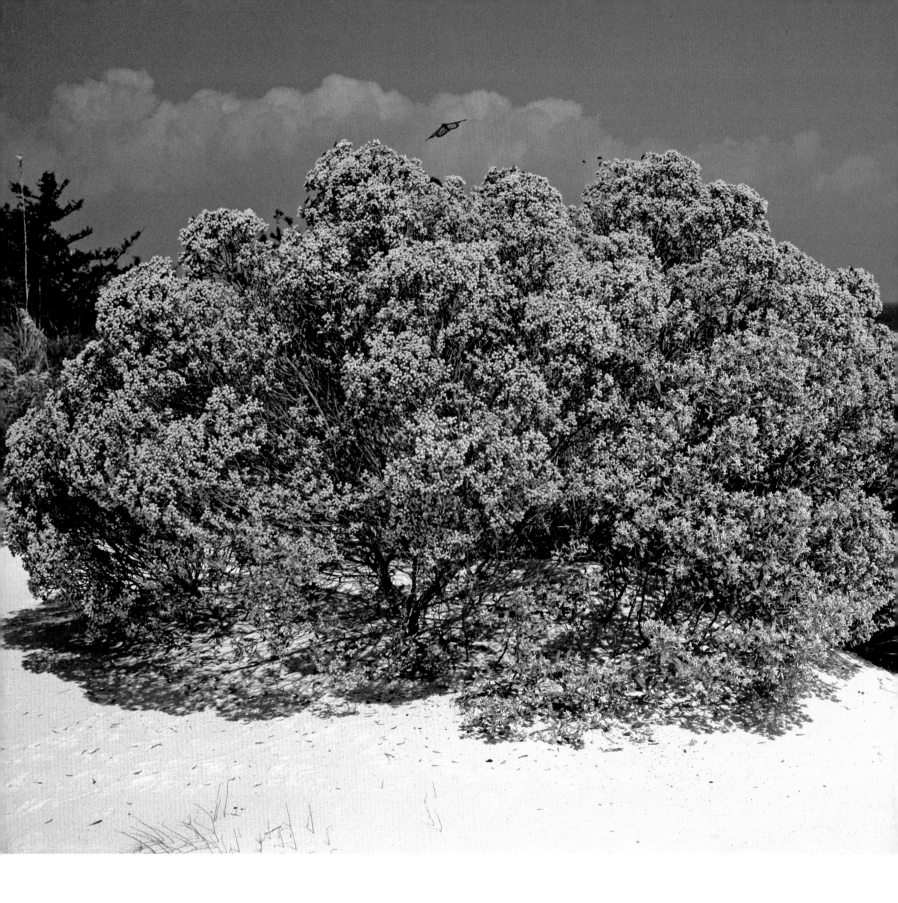

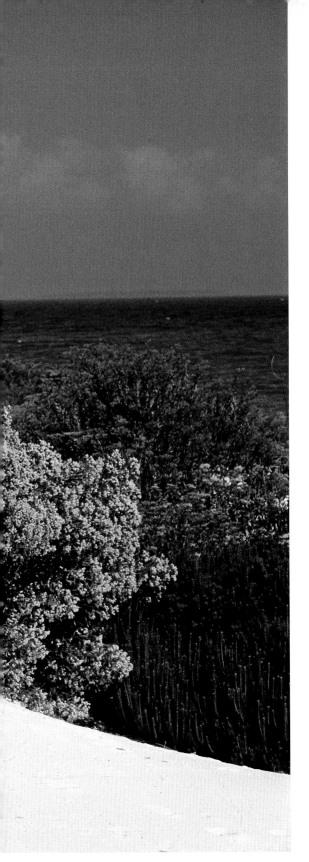

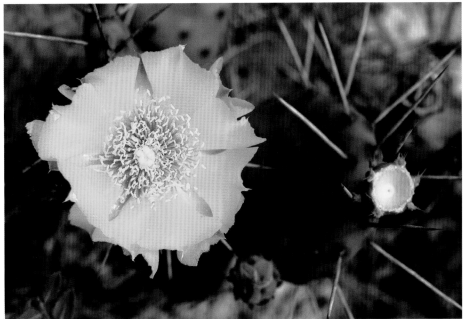

Prickly pear cactus (*Opuntia humifusa* [Raf.] Raf.).
Petit Bois Island, May 1975.

Opposite: Groundsel. Horn Island, October 1978. The blossoms have a strong, sweet odor
which is very attractive to butterflies and other insects.

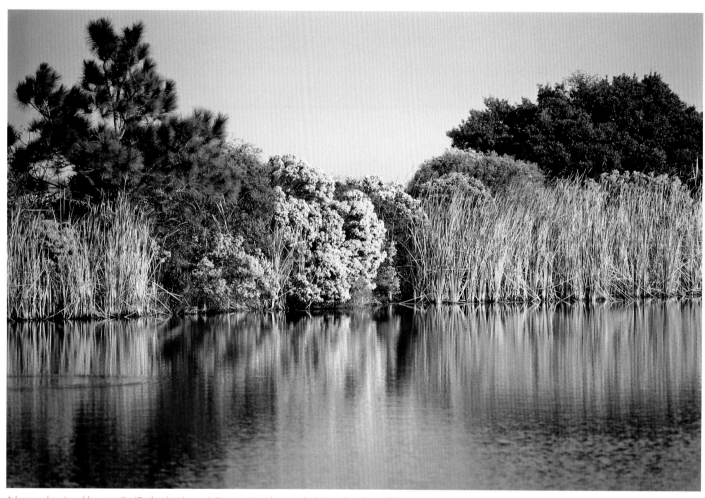

A lagoon bordered by cattails (*Typha domingensis* Persoon) and groundsel (*Baccharishalimifolia* Persoon).
Horn Island, October 1974.

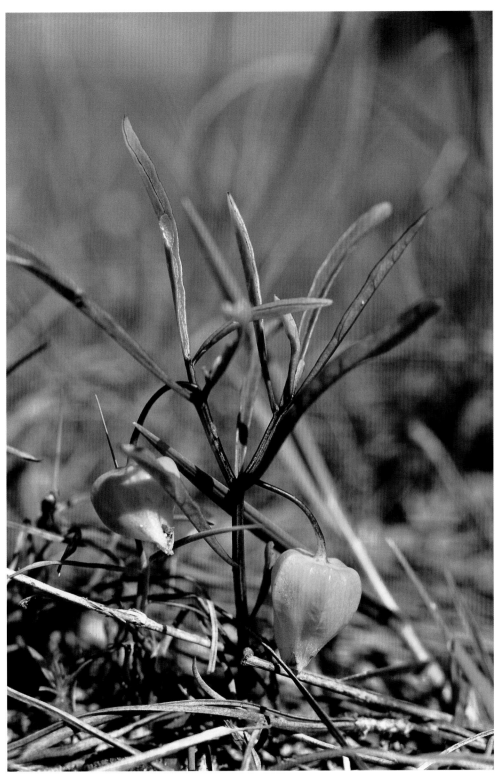

Ground cherry.
Horn Island, May 1978.
Red cherry–like seeds are enclosed
in the paper lantern–like structures.

Cattails in a lagoon.
Horn Island, October 1978.

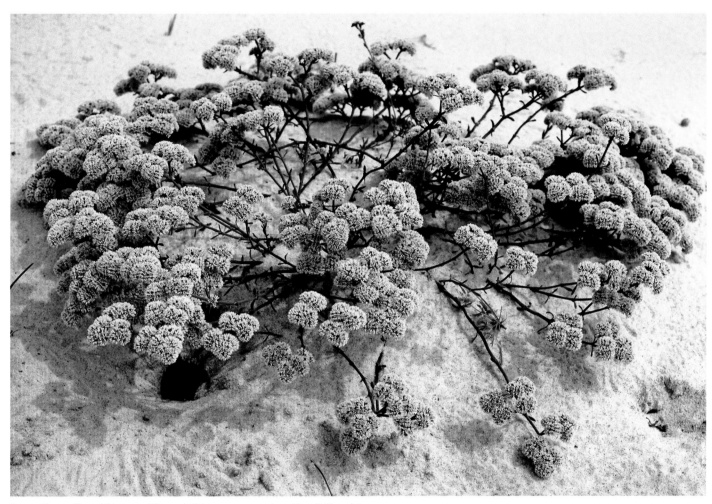

Square flower *(Paronichia erecta* [Chapm.] Shinners var *corymbosa* [Small] Chaudri).
Horn Island, July 1976. Note ghost crab burrow.

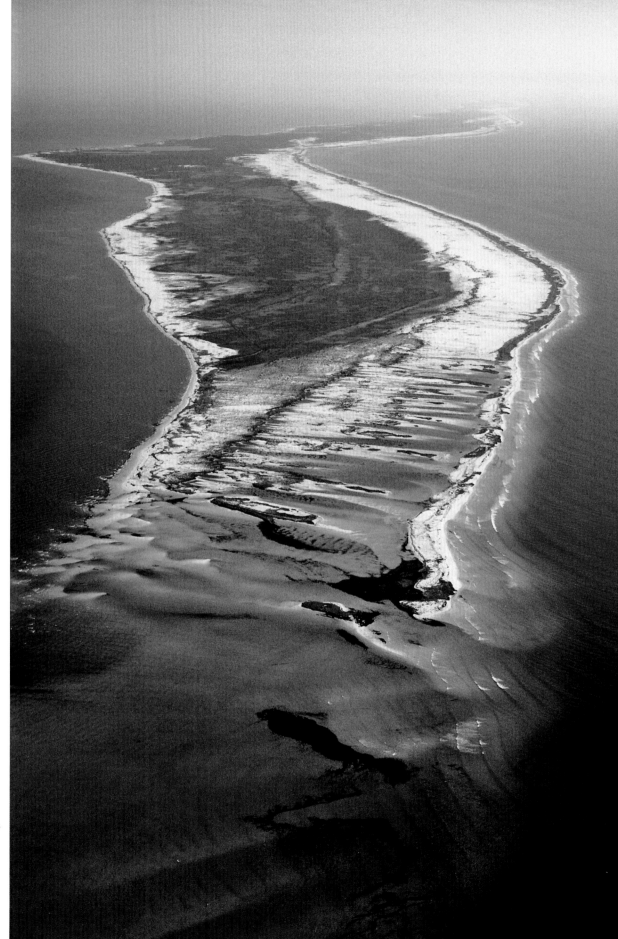

Looking east shortly after
Hurricane Camille.
Horn Island, September 1969.
The western end of the island is
extensively scoured.

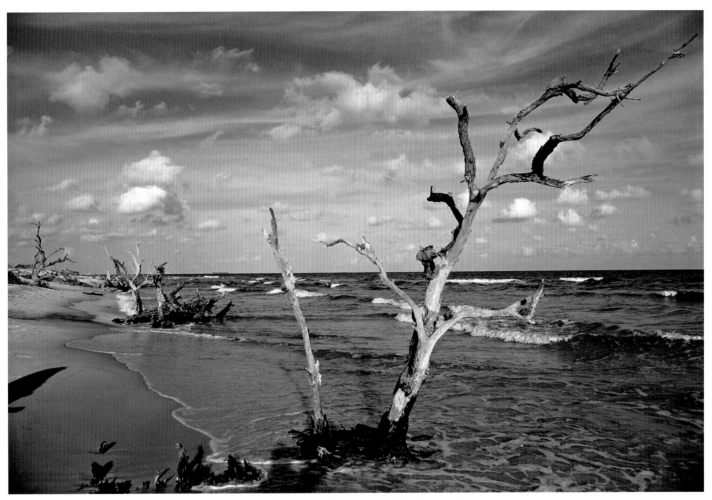

Stranded and dead oaks, south beach, east end. Horn Island, August 1974. The east end of the island erodes, leaving the trees.

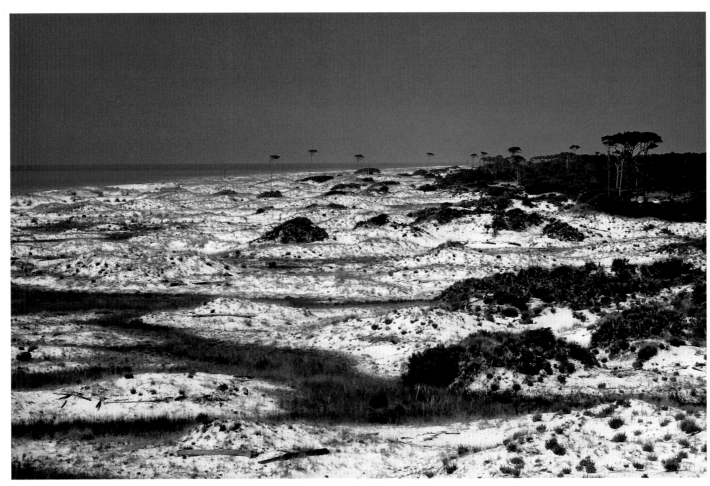

Looking west along south beach dunes. Horn Island, 1964.

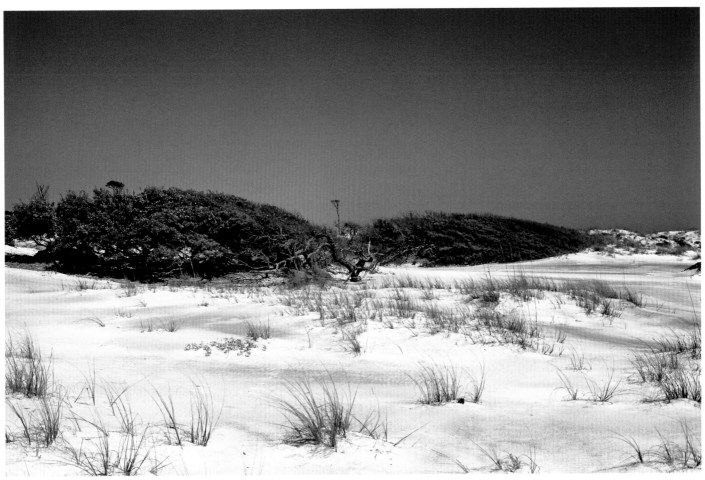

Wind-sculptured live oaks (*Quercus virginiana* Mill.), south beach. Horn Island, April 1972.
Oaks are confined to the easternmost portions of the island.

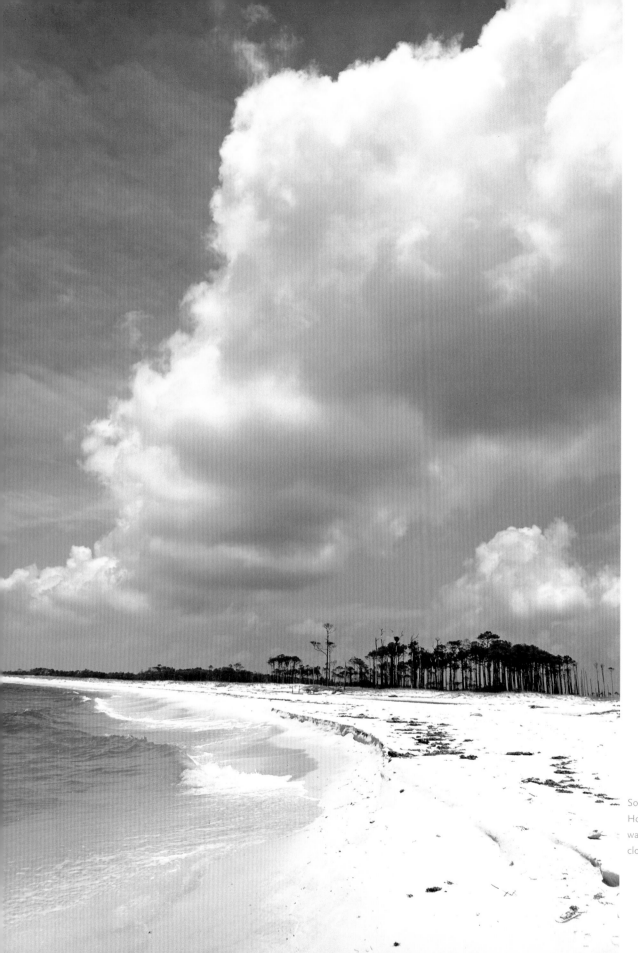

South beach, looking west.
Horn Island, May 1974. During
warmer weather linear cumulus
clouds often form above the islands.

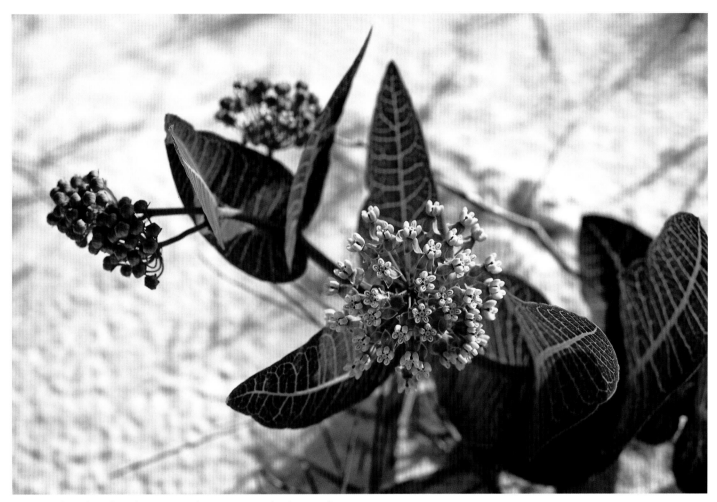

Walter's milkweed (*Asclepias humistrata* Walt.). Santa Rosa Island, September 1973.

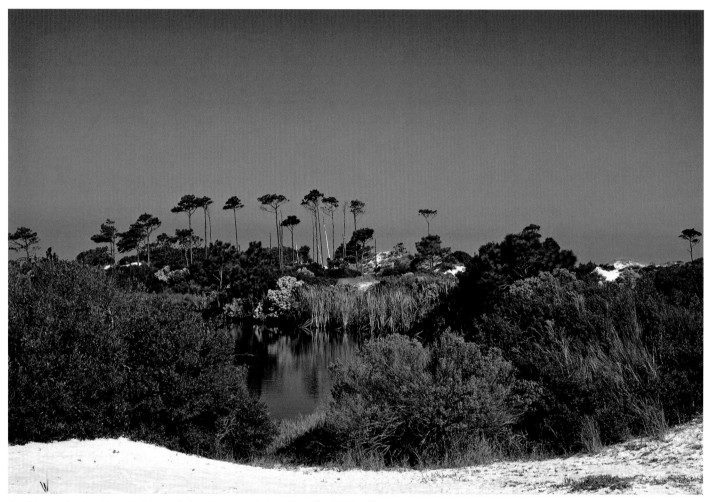

Small lagoon bordered by cattail, groundsel, and wax myrtle (*Morella cerifera* [L.] Small).
Horn Island, November 1974.

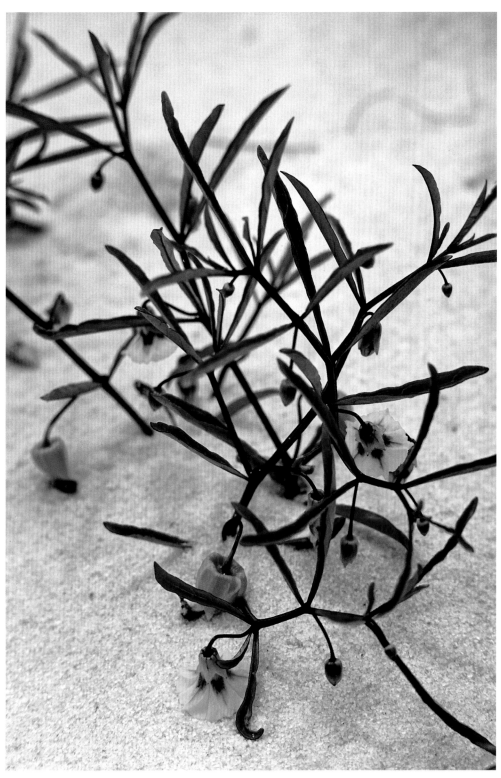

Ground cherry (*Physalis angustifolia* Nuttall).
Horn Island, April 1971.

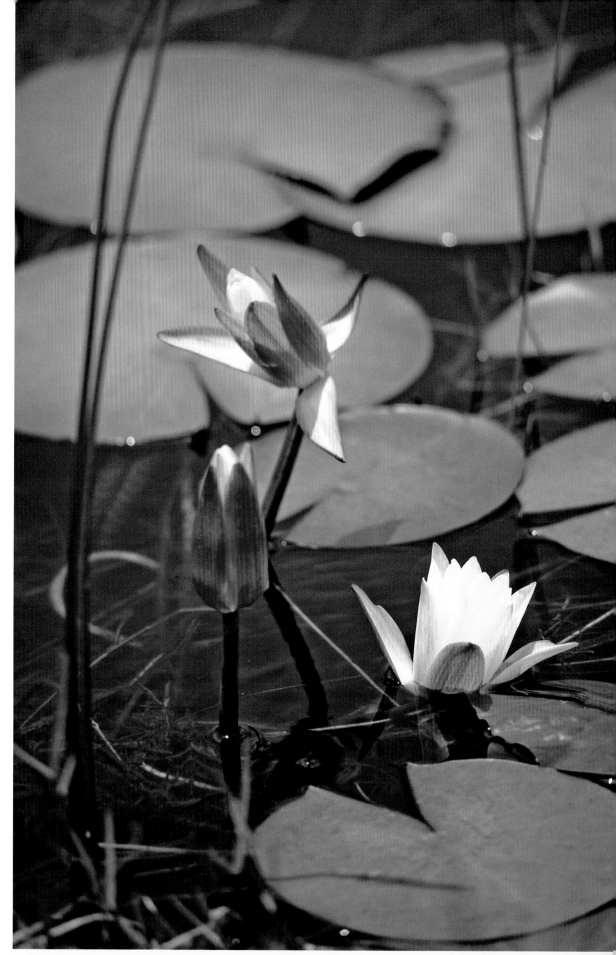

Water lily (*Nymphaea odorata* L.)
in pond north of ranger station.
Horn Island, June 1973.

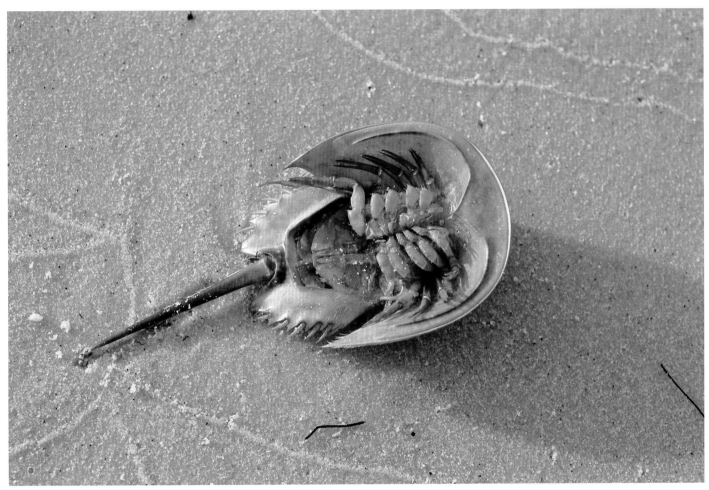

Horseshoe crab (*Limulus polyphemus*), north beach. Horn Island, November 1991.

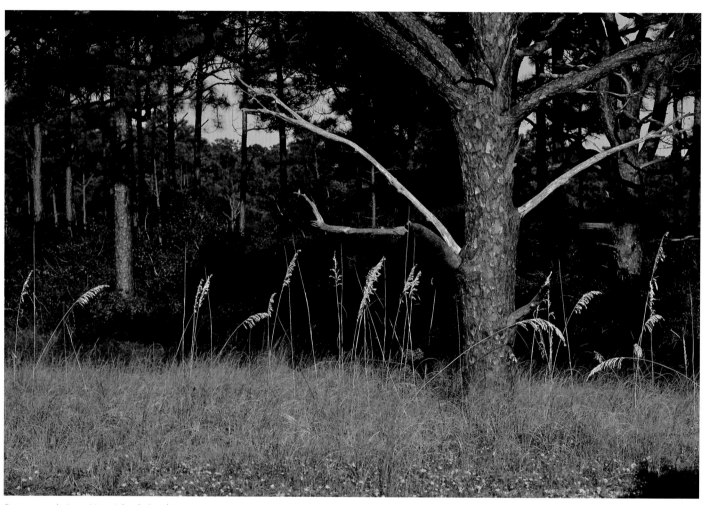

Sea oats and pines. Horn Island, October 1974.

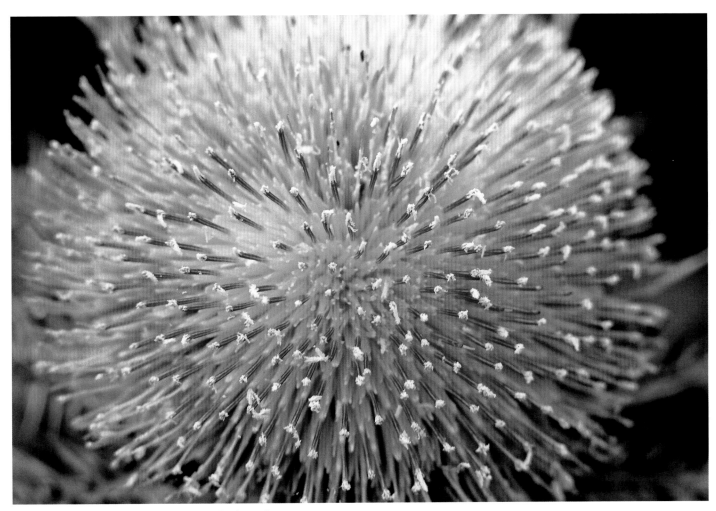

Thistle blossom, a hummingbird's view. Horn Island, March 1967.

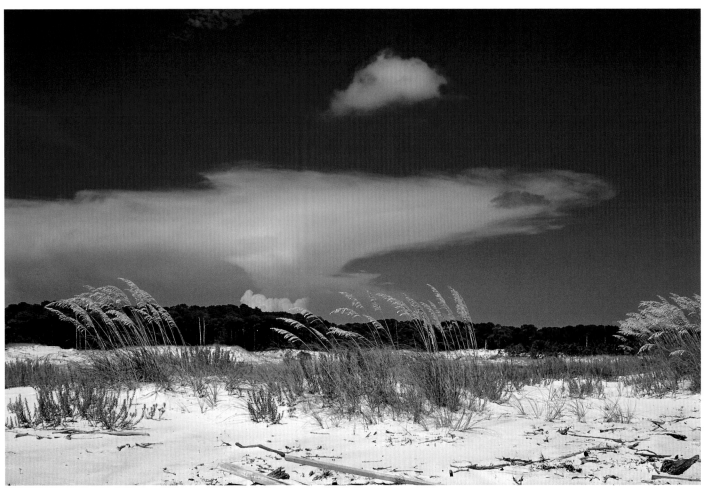

Southward from north beach with sea oats (*Uniola paniculata* L.). Horn Island, July 1980.

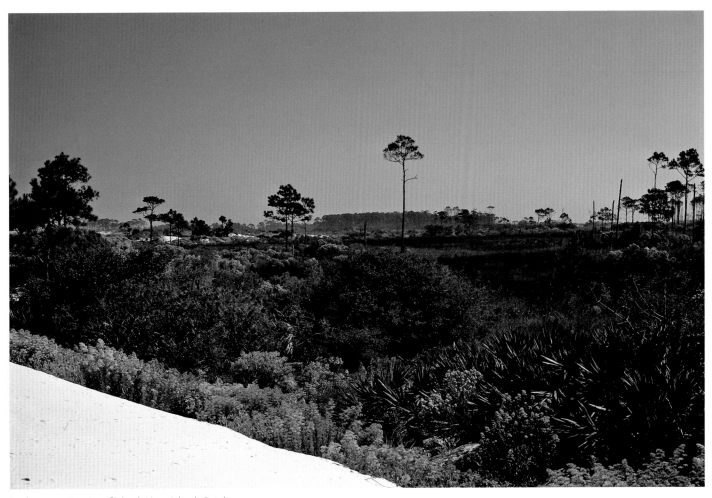

Looking east, interior of island. Horn Island, October 1974.

Yaupon.
Horn Island, November 1972.

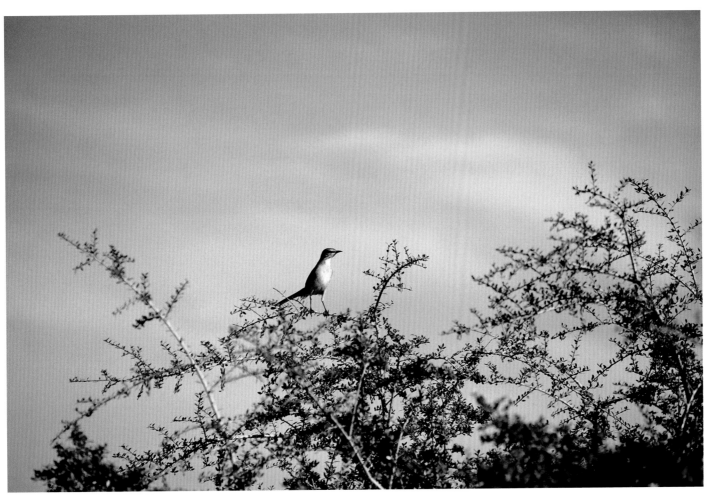

Mockingbird (*Mimus polyglottos*) on yaupon (*Ilex vomitoria* Ait.). Horn Island, October 1987.

Butterfly pea (*Centrosema virginianum* [L.]
Bentham). Petit Bois Island, July 1974.

Sea purslane (*Sesuvium portulacastrum* L.). Petit Bois Island, September 1975.

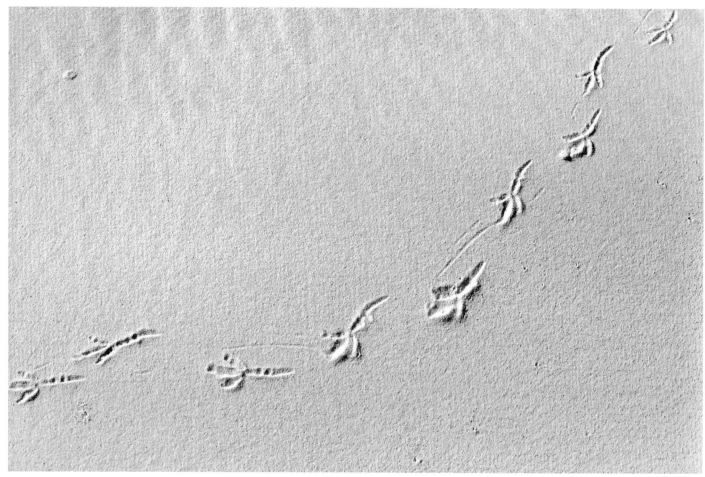

Boat-tailed grackle tracks. Horn Island, November 1970.

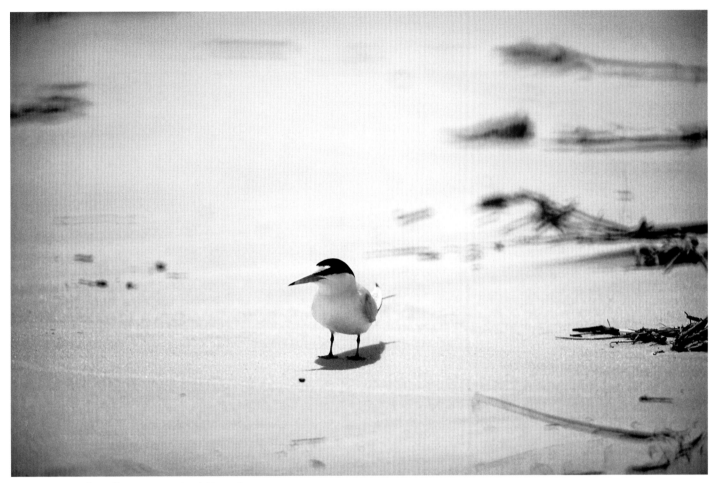

Least tern (*Sternula antillarum*). Horn Island, May 1969.

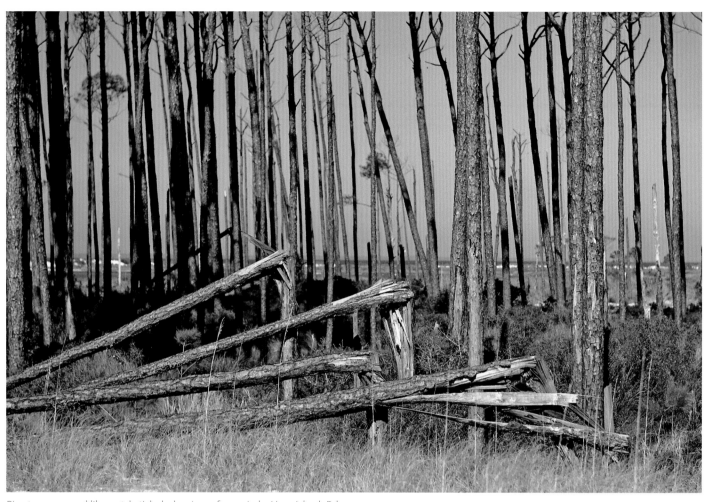

Pine trees snapped like matchsticks by hurricane-force winds. Horn Island, February 1972.

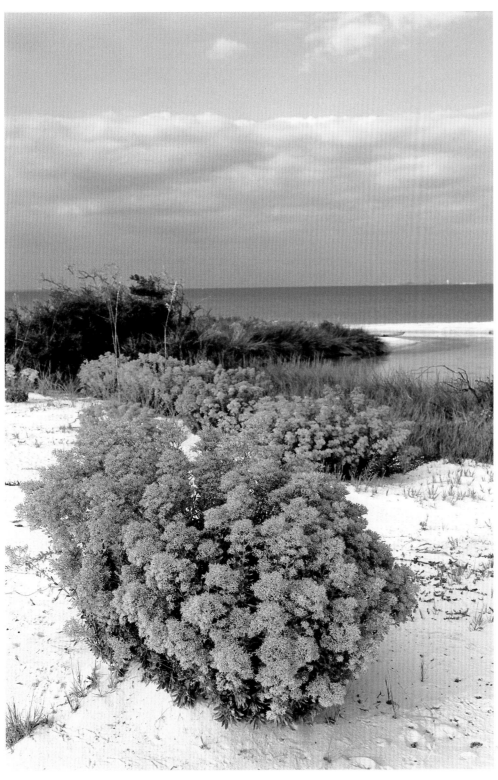

North beach, looking toward mainland.
Horn Island, October 2001.

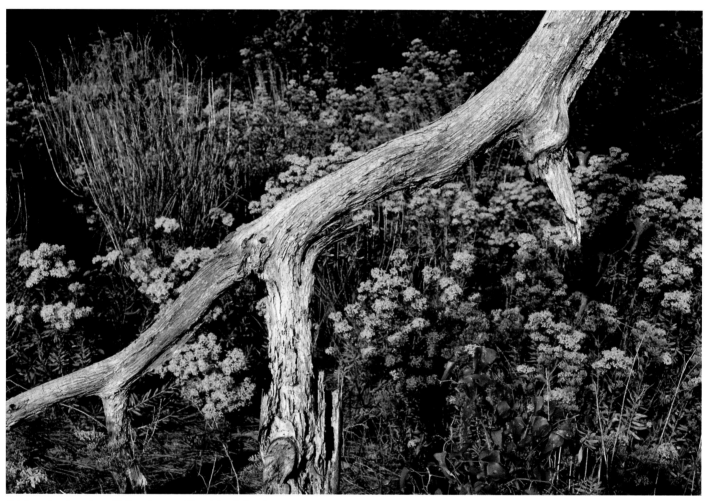

Goldenrod and portion of fallen pine tree. Horn Island, October 1977.

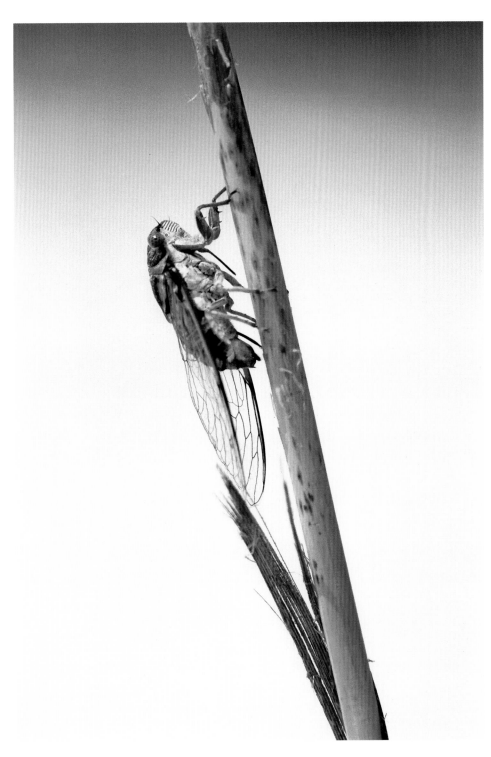

Cicada on sea oat stalk.
Horn Island, September 1974.
The cicada flew onto the stalk immediately
next to me and shortly placed its ovipositor
into the hollow stem.

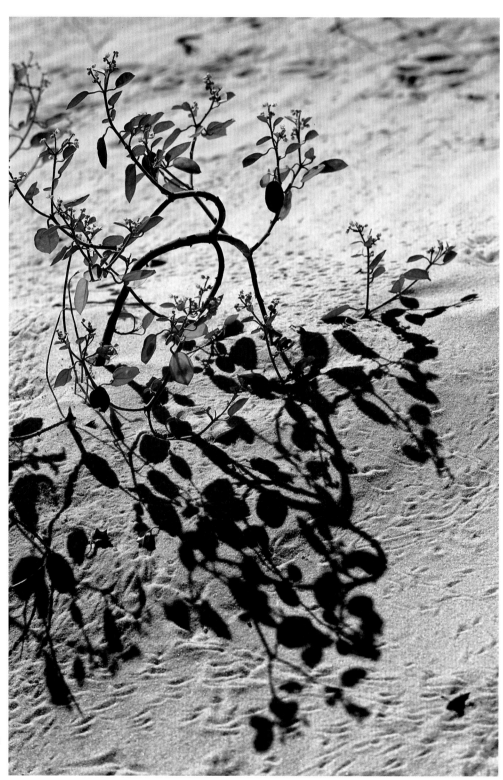

Beach tea/silver leaf croton (*Croton punctatus* Jacq.).
Horn Island, October 1974.

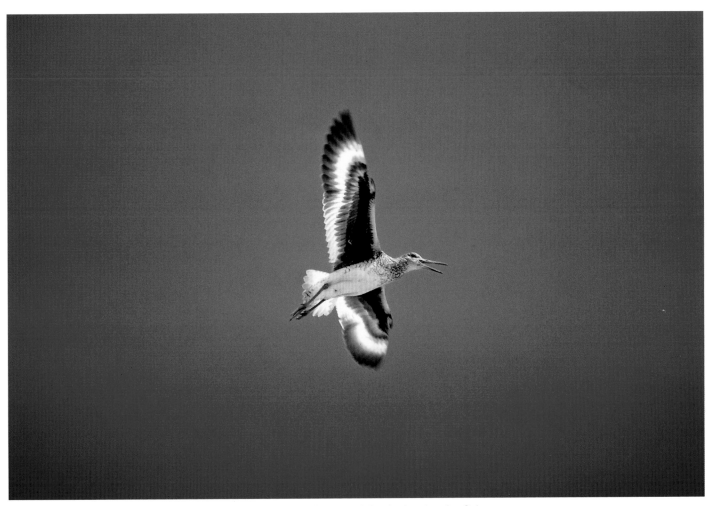

Willet (*Tringa semipalmata*). Horn Island, 1971. The willet is a drab, moderate-sized shorebird until it takes flight and its distinctive wing pattern is displayed.

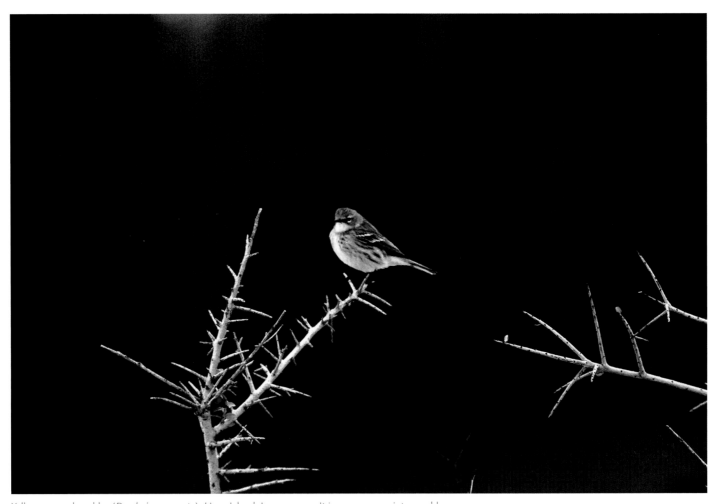

Yellow-rumped warbler (*Dendroica coronata*). Horn Island, January 1974. It is a common winter warbler.

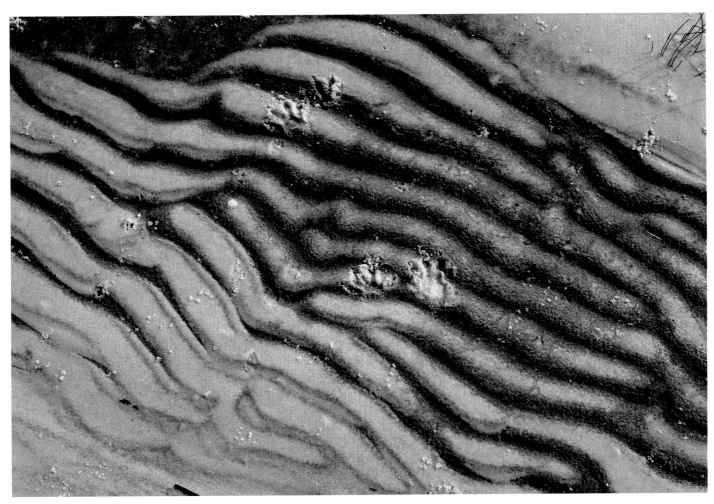

Raccoon (*Procyon lotor*) tracks. Horn Island, April 1973.

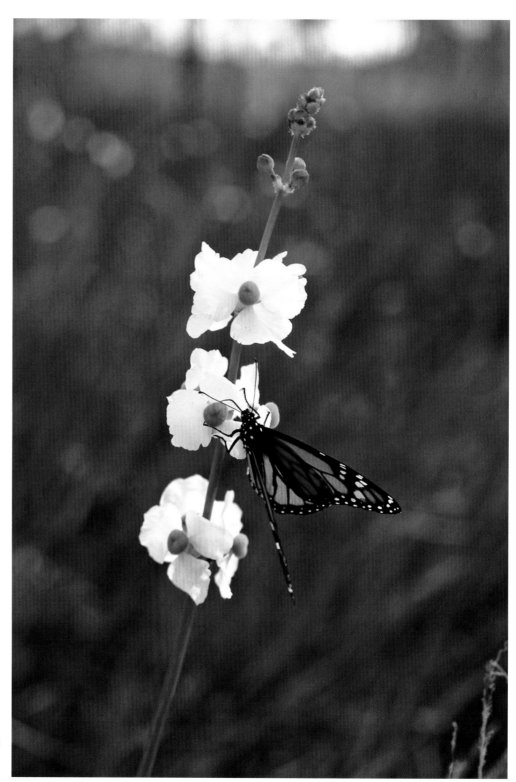

Monarch butterfly (*Danaus plexippus*)
on arrowhead (*Sagittaria graminae*).
Horn Island, October 1978.

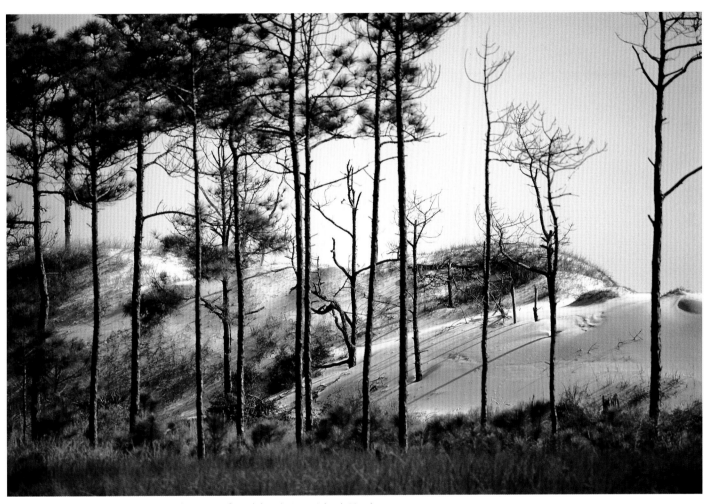

Looking southeast at large dunes at north margin of south beach. Horn Island, March 1972.
Walter Anderson retreated to these high dunes as the water rose during Hurricane Betsy.

Water lily blossom. Horn Island, June 1974

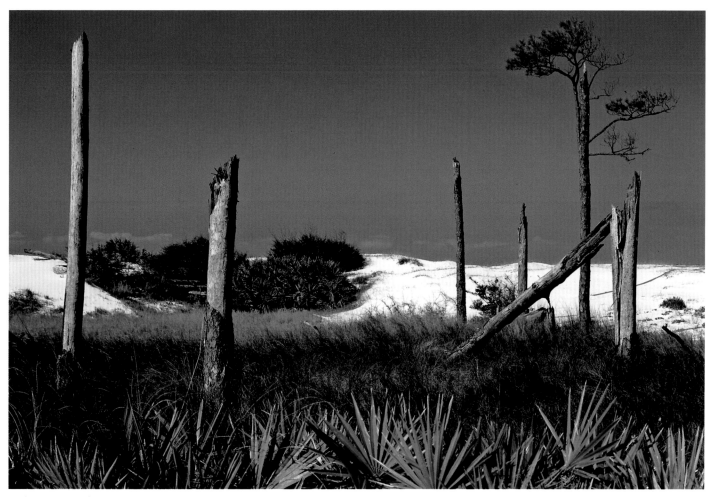

Looking over marsh showing old hurricane-damaged pines and dunes of north beach. Horn Island, March 1972.

Mallow (*Kosteletzyka virginica*
[L.] K. Presl. ex Gray).
Horn Island, June 1974.

Goldenrod, marsh, and pines. Horn Island, October 1978.

Seaside rosemary and smilax (*Smilax bono-nox* L.). Horn Island, November 1972.

Rabbit tracks with a rest stop. Horn Island, June 1974.

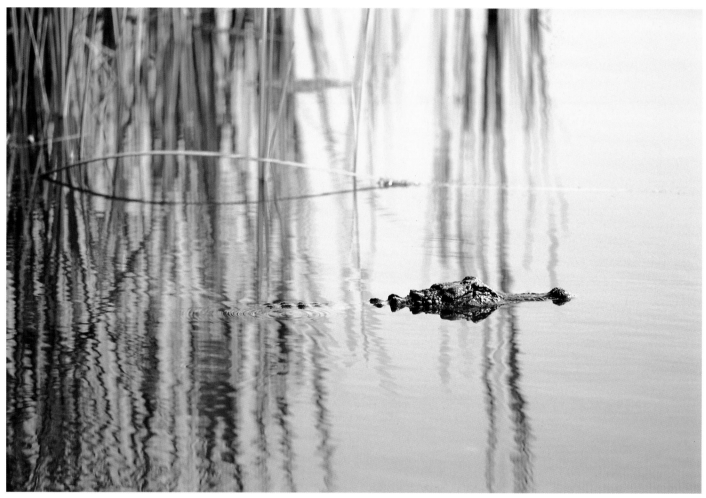

Alligator (*Alligator mississipiensis*) in lagoon. Horn Island, October 1978.

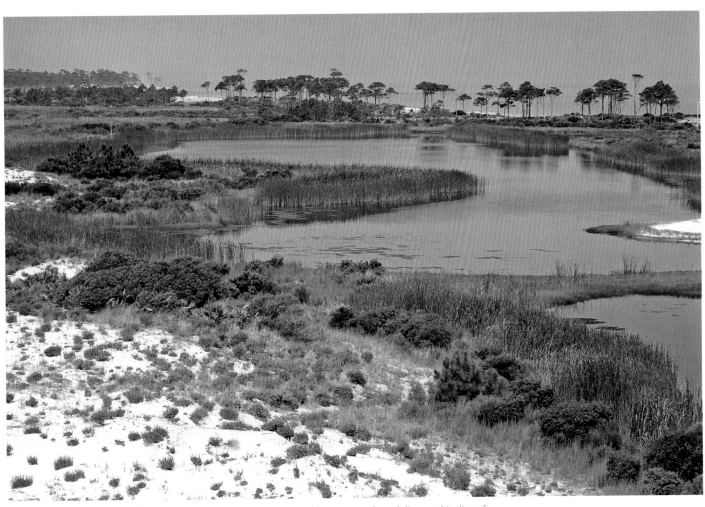

Looking northwest over a small segment of south barrier dunes, central lagoon, marsh, and distant white line of
north beach. Horn Island, 1964.

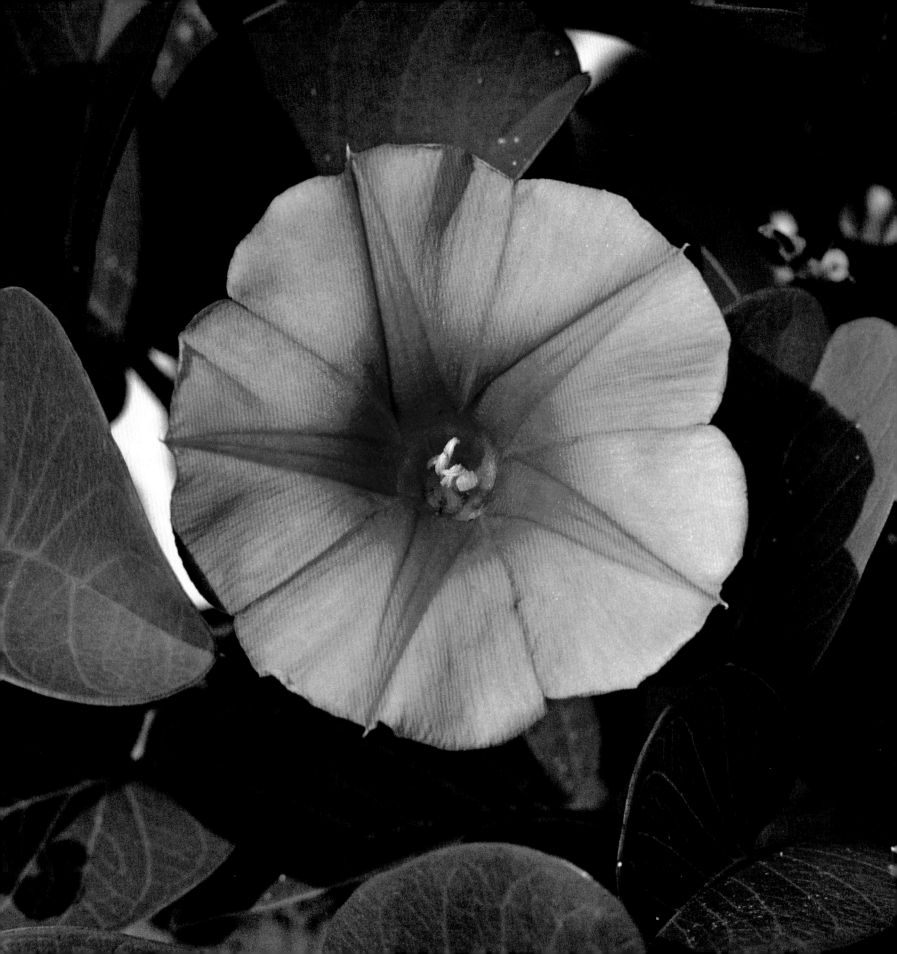

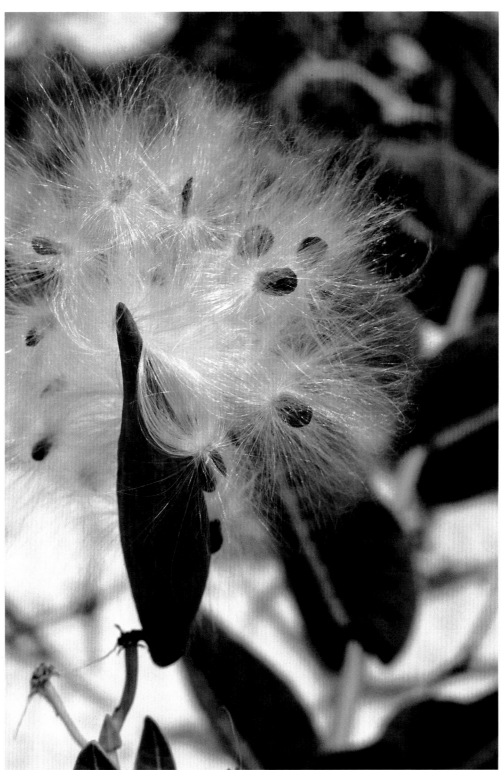

Walter's milkweed with seeds.
Petit Bois Island, June 1966. This is
the only prostrate milkweed.

Opposite: Railroad vine (*Ipomea pes
caprae* [L.] R. Br.), south beach.
Horn Island, September 1974.

A sanderling (*Calidris alba*) on the south beach. Horn Island, January 1978. Sanderlings breed in the arctic and winter along the coasts of the United States, Canada, and Mexico. They are often in groups, running to and fro as the waves ascend and recede from the beach, reminding me of worried diplomats.

Alligator track.
Horn Island, December 1969.

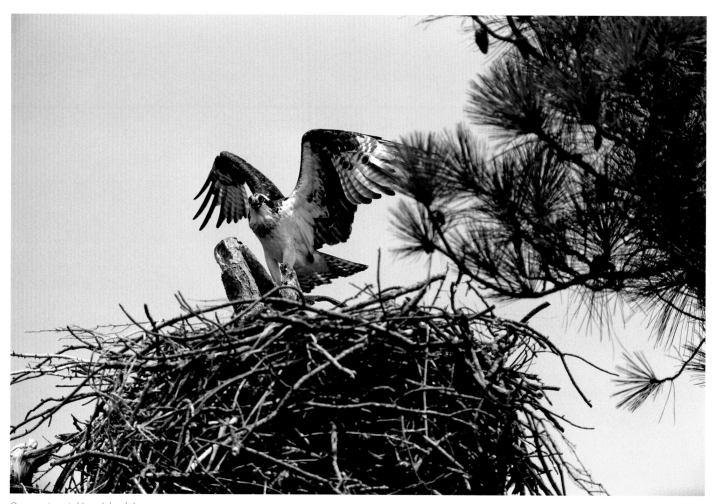

Osprey at nest. Horn Island, June 1974.

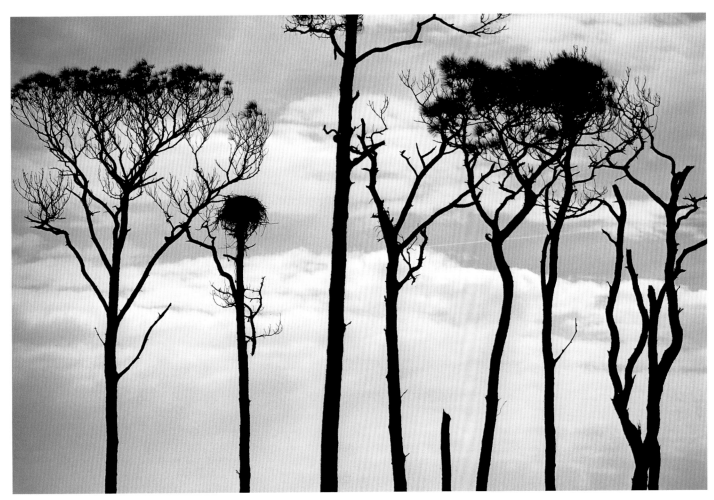

Slash pines with osprey nest. Horn Island, February 1972.

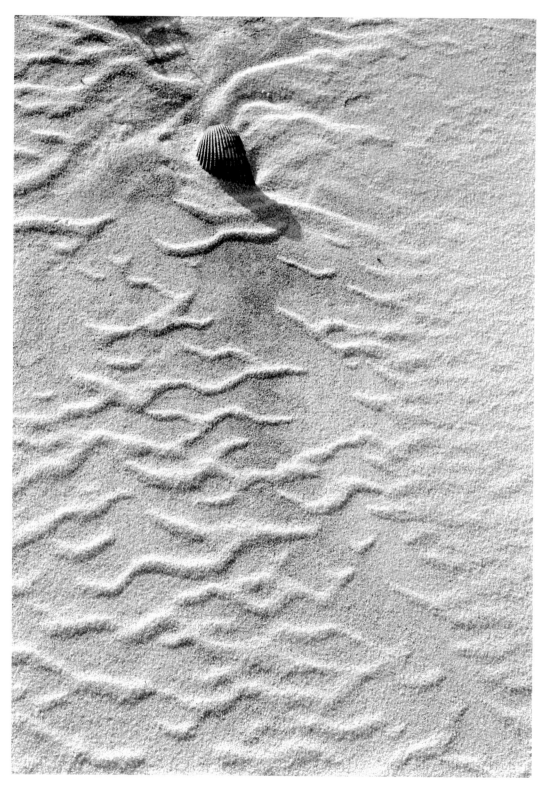

Shell and patterned sand.
Horn Island, March 1987.

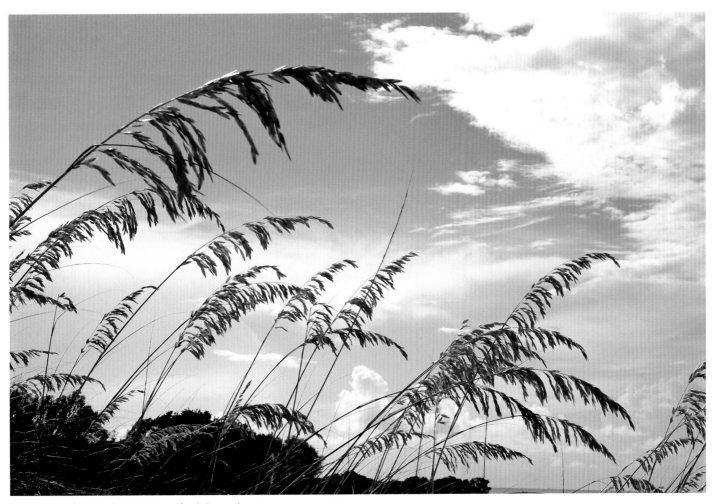

Sea oats (Uniola paniculata L.). Horn Island, September 1974.

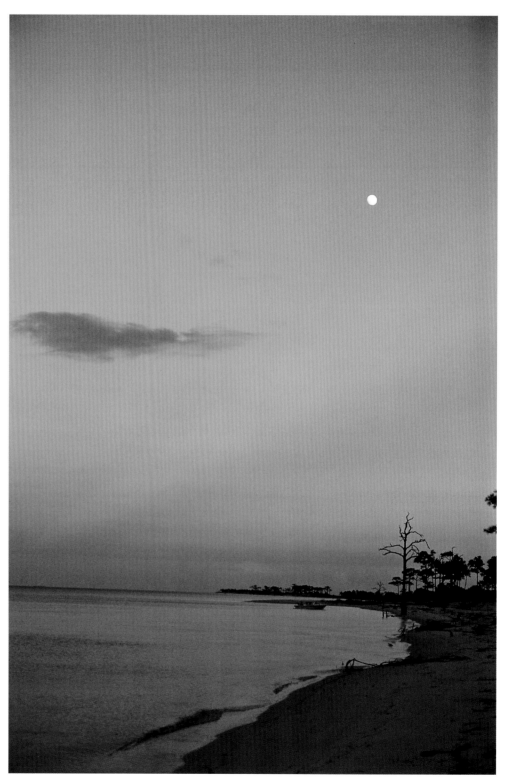

Dusk with risen moon.
Horn Island, September 1974.

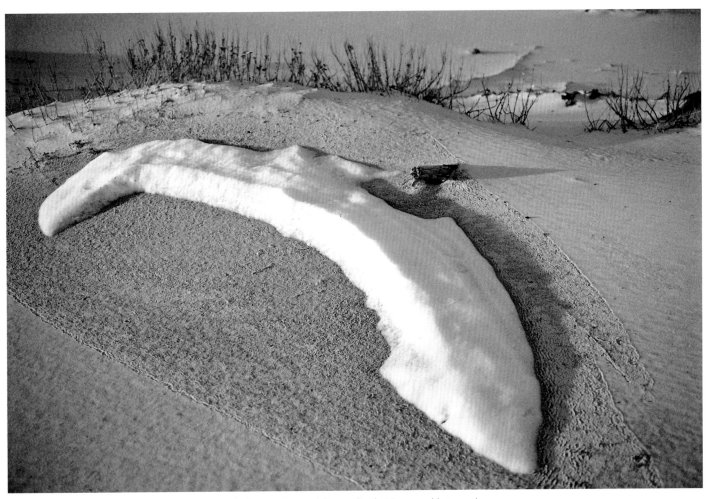

Snow on south beach. Horn Island, February 1973. It had snowed several days earlier, but I was unable to reach the island sooner and most of the snow had melted.

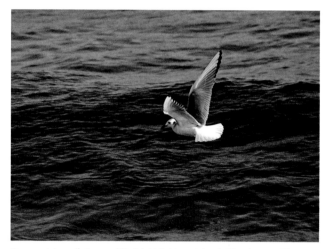

Bonaparte's gull (*Larus philadelphia*). Horn Island, March 1972. These gulls are winter visitors and frequently feed in groups, catching small fish from the surface of the water.

Opposite: Late afternoon. Horn Island, October 1974.

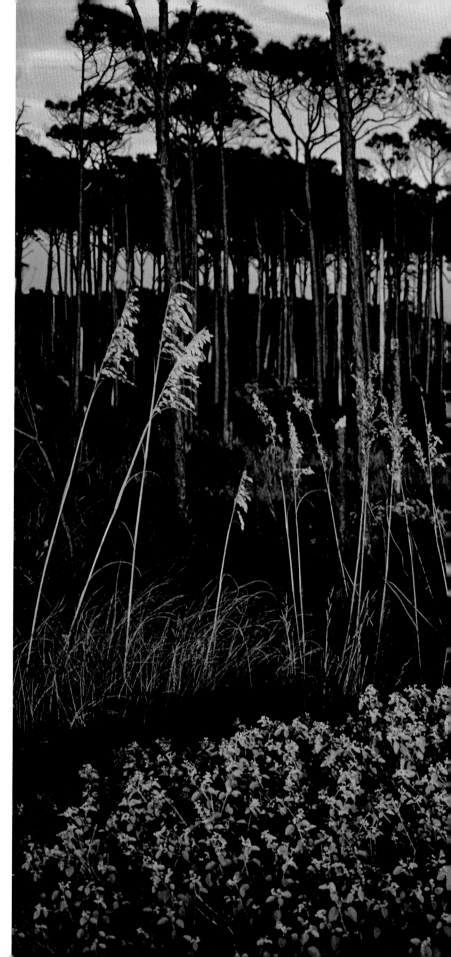

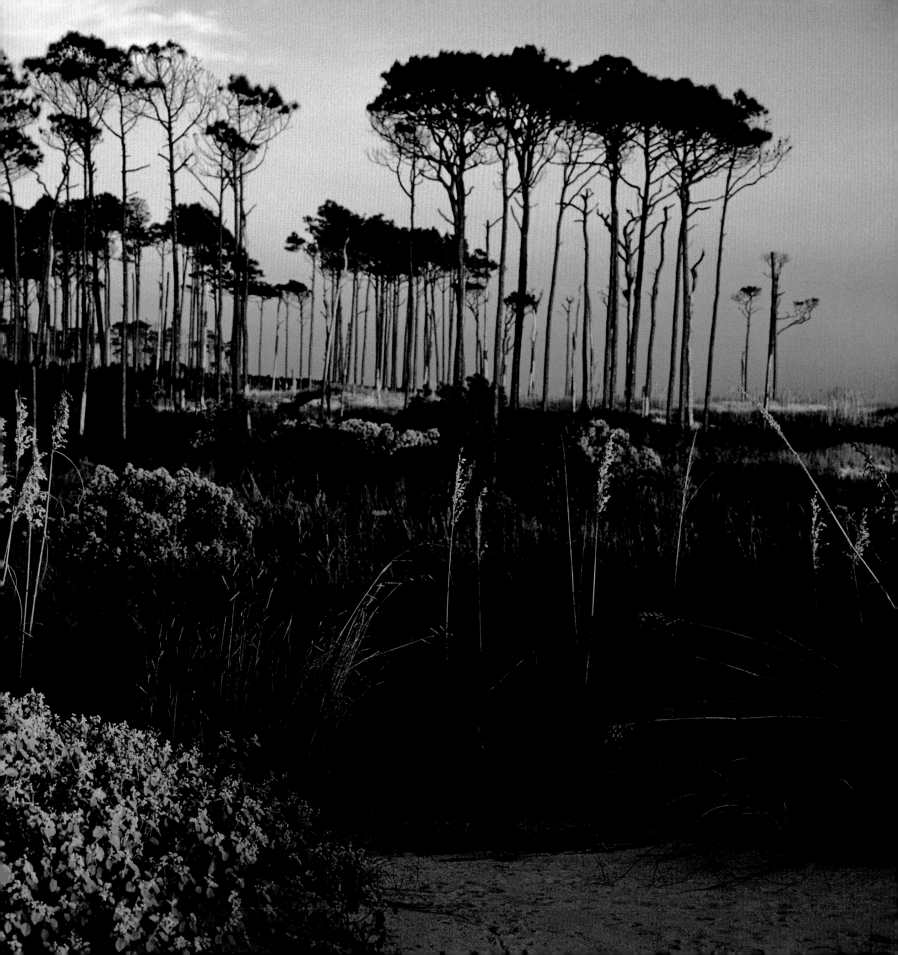

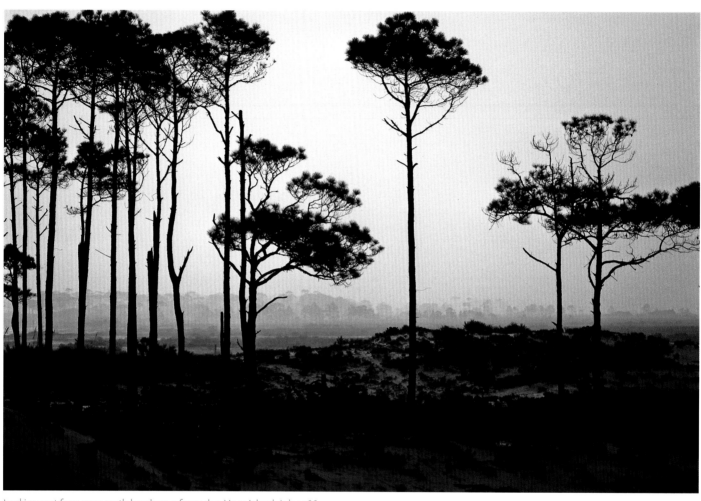

Looking east from near north beach on a foggy day. Horn Island, July 1966.

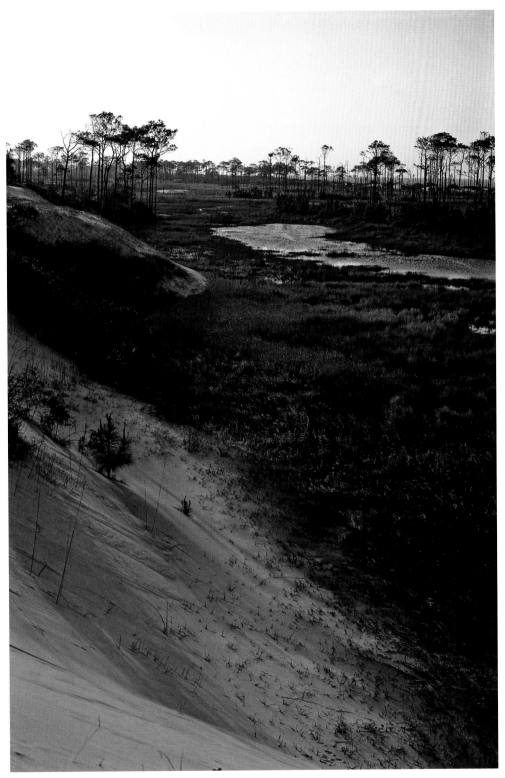

Westerly late afternoon view from high dune.
Horn Island, May 1973.

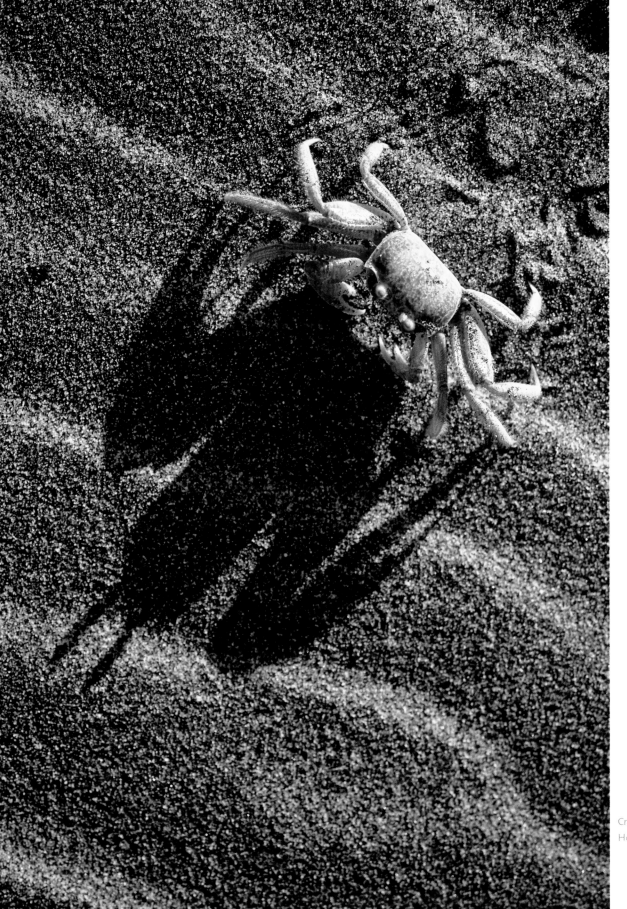

Crab with larger-than-life shadow.
Horn Island, October 1974.

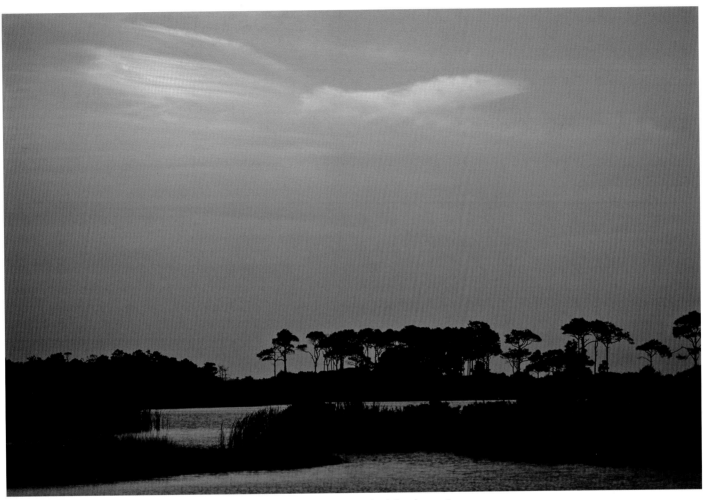

Late afternoon, looking west with a prismatic coloration at the cloud margin. Horn Island, October 1976.

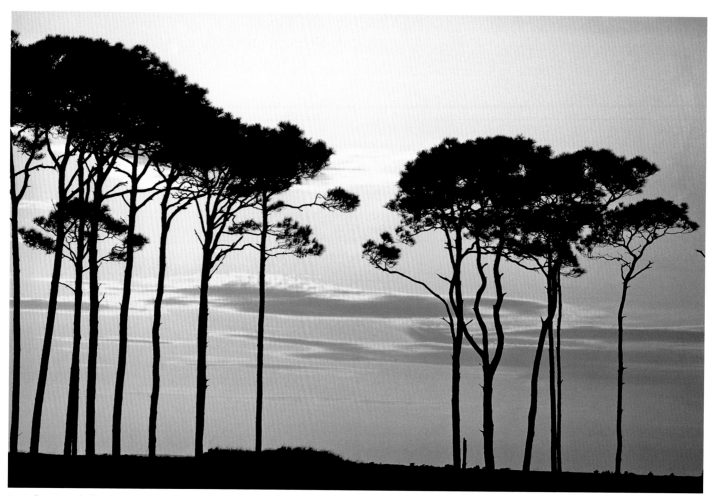

Late afternoon, slash pines and clouds. Horn Island, March 1965.

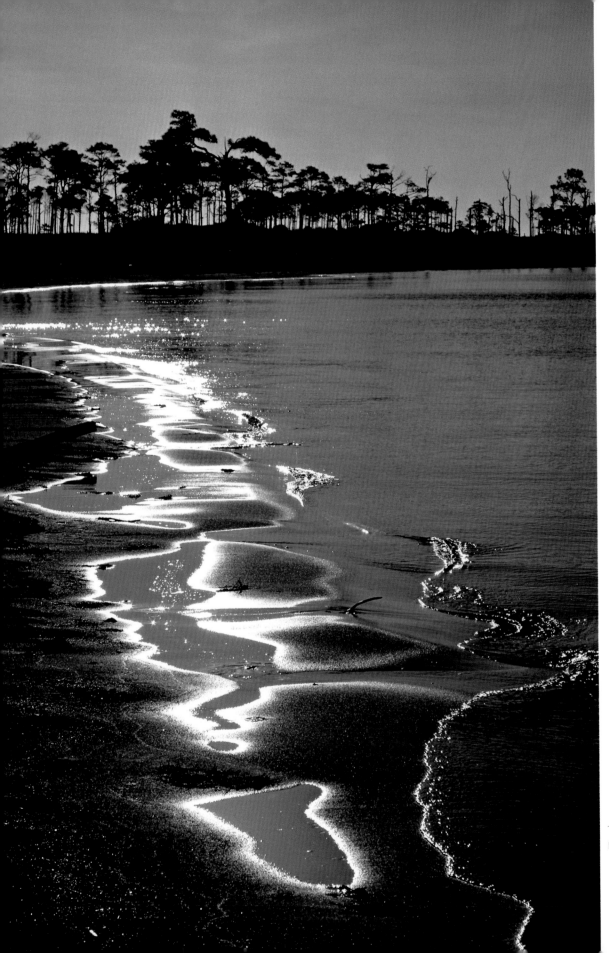

The horseshoe, north beach.
Horn Island, January 1975.

Wind-sculptured live oaks on dune summit. Horn Island, April 1973.

Opposite: Sunset, north beach. Horn Island, June 1974.

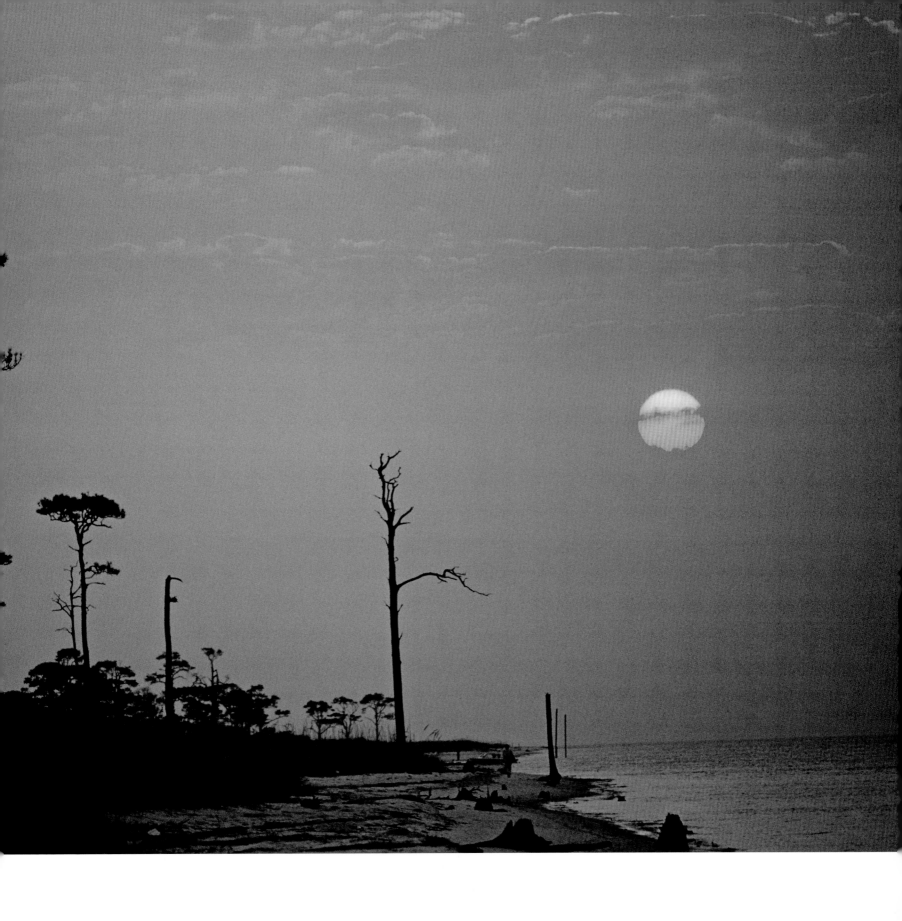

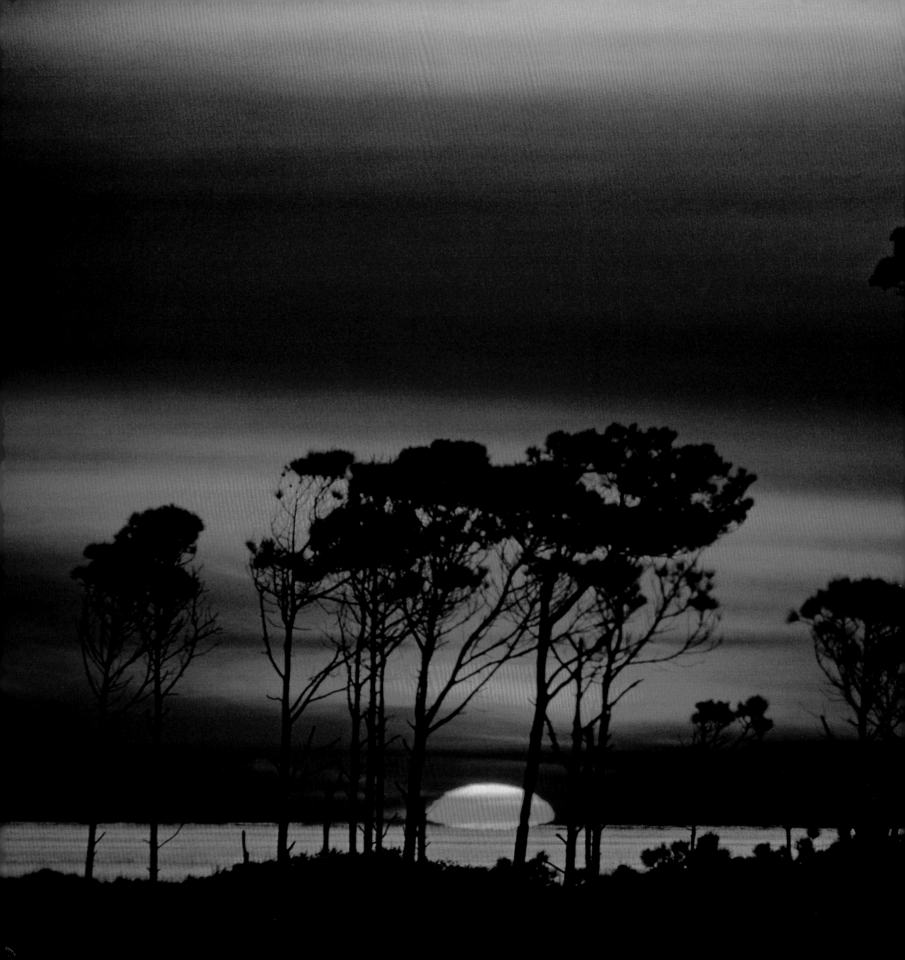

Sunset.
Horn Island, December 1963.

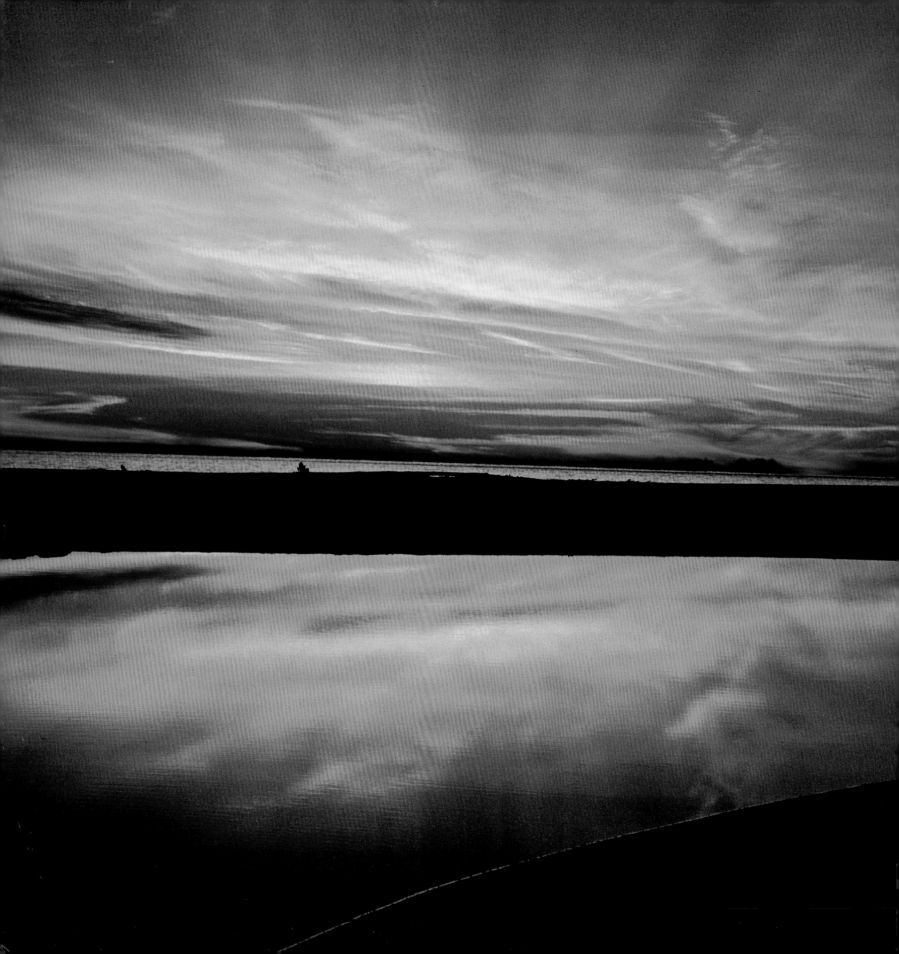

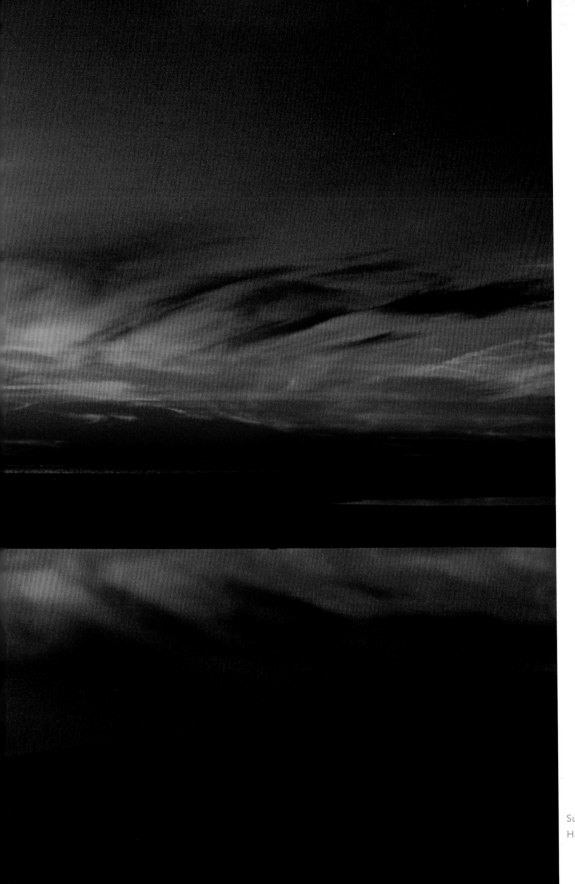

Sunset.
Horn Island, January 1978.

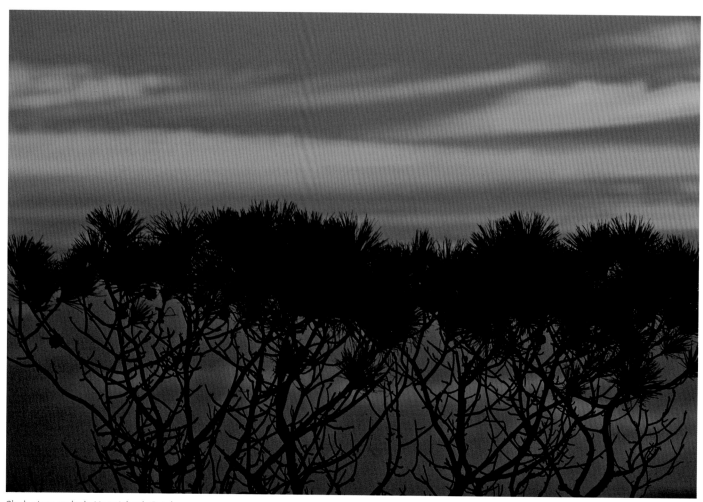

Slash pines at dusk. Horn Island, October 1974.

AFTERWORD

In the bill that established the wilderness, the beaches were all included but not the submerged lands, though the National Seashore boundaries extend out one mile from shore or to the intracoastal canal in the Mississippi Sound, whichever is the closest. The National Park Service interprets this as allowing motorized three-wheeler patrol below mean high tide line in addition to boat patrol. A small boat dock on the north shore adjacent to the ranger station allows for the landing of supplies and is a site for the rangers' outboard boat protection. The only exclusion in the wilderness allows for the ranger cabin and a strip of land extending to the boat dock. The dock is utilized only by the park service. There are no designated campsites, and visitors may camp in areas of their choice providing they do not interfere with nesting ospreys or cause dune or other destruction.

Since establishment of the National Seashore, the islands as well as the mainland have been subjected to what appear to be an increasing number of destructive hurricanes, the most severe having been Hurricane Katrina, which resulted in extensive death of pine trees; in the case of Petit Bois, nearly all of them. The ranger cabin on Horn Island was destroyed and its replacement not occupied until late February 2010.

Cat Island was not included in the National Seashore bill, as the owner at the time objected seriously to it, claiming that he had plans for real estate development. He has since died, and his heirs are of a somewhat different mind. In 2002, they allowed the Trust for Public Land to buy the western half and the southern tip of the T-shaped island for the National Park Service, and negotiations continue for the remaining half, which contains most of the beaches and within which the owners want to retain a small inholding. Hurricane Katrina removed most of the park service's southern tip.

In early 2000, the governor, formerly an oil industry lobbyist and Republican Party chairman, launched a plan for oil and gas exploration in the Mississippi Sound and southward to the state boundary. This aroused a storm of protest from environmentalists, casino owners, and condominium developers, the latter two groups a very significant source of revenue for the state of Mississippi. Before this scenario had run its course, Katrina struck, and the matter has since receded from the headlines, likely temporarily.

There are other threats to the well-being of Horn and Petit Bois, including a plan utilizing water from the Pascagoula River to wash out a salt dome for oil storage purposes. Saline discharges into adjacent waters of the Mississippi Sound might impact marine life as well as avifauna.

We are extremely fortunate to have small areas of wilderness so close to and contrasting with our mainland existence. Though the islands are permanently protected by law, changes beyond their boundaries are capable of greatly diminishing their value, and it behooves all of us who realize their importance to remain vigilant and stand up for maintaining their integrity.